IN PICTURES

IN PICTURES

Text by
Andy Capostagno

Project conceived by
www.jonty.co.za

VIKING

VIKING

Published by the Penguin Group
80 Strand, London WC2R 0RL, England
Penguin Putnam Inc, 375 Hudson Street, New York,
New York 10014, USA
Penguin Books Australia Ltd, Ringwood, Victoria, Australia
Penguin Books Canada Ltd, 10 Alcorn Avenue, Toronto, Ontario,
Canada M4V 3B2
Penguin Books (NZ) Ltd, Cnr Rosedale and Airborne Roads,
Albany, Auckland, New Zealand
Penguin Books India (P) Ltd, 11 Community Centre, Panchsheel Park,
New Delhi - 110 017, India
Penguin Books (South Africa) (Pty) Ltd, 24 Sturdee Avenue, Rosebank,
Johannesburg 2196, South Africa

Penguin Books (South Africa) (Pty) Ltd, Registered Offices:
Second Floor, 90 Rivonia Road, Sandton 2196, South Africa

First published by Penguin Books (South Africa) (Pty) Ltd, 2001.

Copyright text © Andy Capostagno
Copyright photographs © Touchline Photo, Cricinfo, Rian Botha,
Queensland Newspapers
Picture on pages 96 and 97 by Richie Ryall
Project conceived by www.jonty.co.za

ISBN 0 670 04780 5

Design: Mouse Design
Printed by: CTP Book Printers, Cape Town

Contents

Jonty – In Pictures

Acknowledgements

Jonty – In Pictures

With special thanks to:

The professionalism of the Penguin Books team that completed this
project on a very tight deadline and for their valuable input in making
this book a reality.

Andy Capostagno for injecting enthusiasm by tackling the project
'boots and all'.

Touchline Photo for their outstanding quality of service in arranging
the bulk of the photographs and for responding to requests
with such efficiency.

Cricinfo and Rian Botha for their support and contributions.

Queensland Newspapers for granting permission to use their
World Cup picture.

Everyone at www.lanx.co.za for their assistance with various graphics.

Digby and Tish Rhodes for digging in their
personal archives.

Mike Bechet for taking time to share his thoughts and comments.

Everyone else who was harassed for pictures, comments and
information to complete the project.

Jonty Rhodes, for creating the pictures in this book, and for the time
and effort to lend context to the story.

To stay in touch with Jonty, please visit his personal web site at
www.jonty.co.za

Introduction

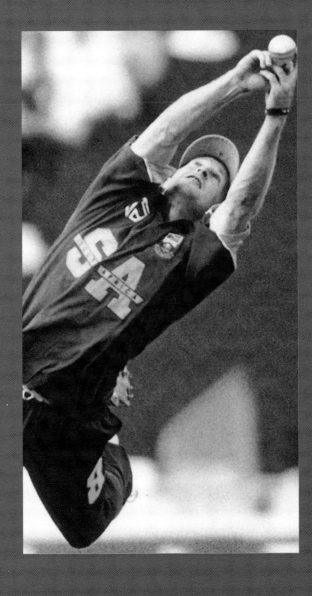

Introduction

Jonty – In Pictures

Leafing through the scorecards of old cricket matches reveals who got runs and who took wickets, but there is no remarks column. How the runs were got and why the wickets were taken is a mystery, but at least the names of the protagonists are written down.

It is a different story for the fielders. History records those who took catches; it draws a merciful veil over those who dropped them. As for run-outs, as far as written history is concerned there is no difference between a direct hit on the stumps from 30 metres, and two batsmen arguing vehemently in mid pitch while the fielding side debates which of the two it chooses to send back to the pavilion.

For the first 200 years of organised cricket's recorded history, fielders tended to be people who got in the way. George Parr's nineteenth-century touring team of professionals regularly played as 11 against 22. How his batsmen threaded the ball through such a crowd is not recorded, but presumably a good number of the fielders fell over each other and an equal number couldn't catch a cold.

A century earlier on Broadhalfpenny Down in Hampshire, David Harris, Hambledon's star bowler who suffered from gout, used to sit in an armchair at fine-leg between overs. From that position it is unlikely that he was accustomed to racing around the boundary and hurling the ball in to the wicketkeeper like an Exocet missile.

The first fielder who regularly got rave reviews was probably the great West Indian all-rounder, Learie Constantine. Before he was knighted and made the House of Lords his second home, Constantine lit up the 1930s with his exploits. It is alleged that once, in a Lancashire League match, Constantine completed a caught and bowled on the cover boundary, shouldering colleagues out of the way in his race to completion.

From about the same era onwards Australian touring teams always seemed to have good arms and in the 1950s wicketkeeper Wally Grout would instil his own sense of tidiness upon his fielders by simply ignoring any throws that did not come straight to him at the stumps.

In the 1960s Colin Bland set a new standard of fielding excellence. On a wet day during a Test match in England, the BBC cameras recorded a display by the South African maestro that revealed what his contemporaries already knew; when Bland shied at the stumps he never missed. But in historical terms Bland was a freak. He was the master of a style that would not be properly appreciated until the world became seduced by one-day cricket a decade later.

The first great fielder of the one-day era was Derek Randall. A ragamuffin from Nottingham, Randall patrolled the area in front of square on the off side like a bag

lady on speed. He would start his own run with the bowler, and if the bowler happened to have a long run, like Bob Willis for instance, that meant kicking off from the boundary boards. By the time the bowler was in his delivery stride Randall was sprinting, yet when the ball was hit anywhere near him he could change direction in mid-stride, hoover up the ball and pounce.

He announced himself at Trent Bridge in a Test match against Australia in 1977. The Australian opener Rick McCosker made the mistake of taking three strides down the pitch at the non-striker's end. When Randall fielded the ball in the covers, McCosker turned to walk back to his crease, only to find Randall already there and playfully removing one bail.

Some years later, in a match at Lord's to celebrate the bicentenary of the MCC, Graham Gooch ran down the pitch to drive the off-spin of Roger Harper. The lithe West Indian stuck out a hand, collected the ball and in the same motion threw down Gooch's stumps with the batsman well short of his ground, an action so shocking that some of the crustier members in the pavilion wondered whether it was a form of cheating.

When South Africa was readmitted to international cricket in 1991 they played three matches in India, losing the first two and winning the third. While the team at times bowled and batted with distinction it was clear that the 20 years of isolation had left South Africa behind the rest of the world in the one-day game. Principally, they were naïve in the field.

The short tour was a prelude to the fifth Cricket World Cup, which began in Australia in February 1992. If South Africa was to compete at the highest level something new was needed. The something new turned out to be Jonty Rhodes.

Until Rhodes came along even the greatest fielders were largely there as ornaments. Batsmen knew that Bland, Randall and Harper were deadly so when the ball went near them they stood their ground. Rhodes was different; he was an offensive weapon. Not just a defender of runs, but an attacker of batsmen. It was as though the captain had an extra bowler up his sleeve.

Never in the history of the game could it be claimed of anyone, as it was of Rhodes, that he was in the side for his fielding. But there was, and still is, a lot more to the man than that. In the early years of his international career his batting average was poor, but he had the priceless habit of making runs when they were really needed.

There are two things that people remember about South Africa at the 1992 World Cup. One is Rhodes' run out of Inzamam-ul-Haq; the other is the impossible task

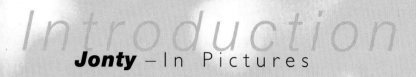

handed to Brian McMillan and Dave Richardson after a rain delay in Sydney, of scoring 21 runs off one ball.

But in that semi-final against England it was Rhodes' 43 off 38 balls that made the chase possible in the first place. He helped bring the target down to 46 off 30 balls and if South Africa had gone on to win the game that might have been the key innings.

It was also in Sydney two years later that Rhodes scored the most significant runs of his Test career. Everyone remembers Fanie de Villiers' magnificent bowling on the last day that took South Africa to victory in the second Test. But he would never have had the opportunity to win the match if Rhodes had not scored 76 not out in South Africa's second innings of 239. The next highest score was Gary Kirsten's 41 while Rhodes supervised the addition of 36 runs for the last wicket with Allan Donald.

But by his own admission Rhodes' batting technique in those days was a mess. In the mid-90s he was dropped from the Test team and forced to rebuild his batting from scratch. That he did just that with huge success is another of the stories ignored by people who believe that he is just a great fielder.

The second half of Rhodes' career really begins with his century against England at the Lord's Test of 1998. At the end of that momentous day he added his name and his score written on sticky tape to the honours board in the South African dressing room. In brackets beneath he wrote 'Batsman, not fielder'.

Jonty Rhodes had just turned thirty-two when we met to speak about this book. He had retired from Test cricket the previous year and was now wondering if he had made the right decision. He felt a little long in the tooth to still be hurling himself around in the covers and had spent some time in season 2000/2001 'hiding' in the slips.

He said, 'But when cover dives over the first ball of the day and it goes to the fence for four and the captain looks at me in the slip cordon and asks the question, it's very difficult not to cave in and go to cover.'

The point is that although he's in good condition, he won't be around to thrill us much longer. This book is a celebration of what Jonty Rhodes has given to South African cricket over the last decade. The pictures within reveal what the scorecard cannot; that it was (and still is) worth a day's walk just to watch Jonty Rhodes field.

Andy Capostagno
Fancourt
August 2001

Early Days

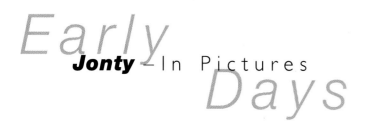

Jonty went to Maritzburg College and became a sporting icon during his time there. Here are some extracts from his school reports:

JONATHAN NEIL RHODES

'In the field we were most fortunate to have some outstanding fielders. Rhodes is clearly the best fielder in the last three or four years at this level, from any school. On the hockey field and as an under-13 boy in the under-14A team, his ability was even more superior to that of his peers. Twenty-three games and eight field goals as well as a Natal under-19 Schools selection were a just reward for his efforts this season. Rhodes is the youngest ever Natal Schools hockey selection.'

A 1985 hockey report says of him ' ... his reading of the game was quite superb whilst his vision and hard running on and off was a pleasure to watch.'

'The whole team followed his example and the ground fielding and throwing in, in particular, were outstanding.'

His player critique said the following: 'He very soon justified his selection as captain with his astute cricket brain and undoubted skills in interpersonal relationships. A fine, attacking opening batsman and a great runner between the wickets, he ensured College a sound opening platform on many occasions. A magnificent fielder, he held

Playing tennis at Hilton tennis club, age 6.

Left in the dust playing soccer for Shamrocks under-8 football team, age 6, in Pietermaritzburg.

on to some great catches and was instrumental in running out many opposing batsmen with the unerring accuracy of his throwing. He is a credit to the cricket traditions of College.'

Jonty's coach for both cricket and hockey at Maritzburg College was Mike Bechet. He remembers the precocious boy:

'In 28 innings Jonty scored 780 runs at an average of 30, whilst he was selected for the Natal Schools as well as the South African Schools teams. Needless to say, as a hockey captain in 1986 he led a young team with much success, in fact his selection as captain of the Natal Schools team as well as his selection as vice-captain of the South African Schools team underlined the wide respect he had gained in hockey circles.

'Rhodes was a penalty corner stopper of incredible consistency and his already well-established hand/eye co-ordination played no small part in his success at this skill, a skill he would later perform in all the provincial and national sides he would represent.'

My old coach Mike Bechet, and me at the christening of his son, my godson Nicholas, in 1993.

Jonty – In Pictures

Early Days

In 1987 he had completed a career of 110 games during which time he had scored 125 goals, another record. Dedicated to the cause as always, he fulfilled his athletics commitments to the school in an otherwise busy year. In his last season on the track, he won the long jump (6,55m), the triple jump (13,05m), 100m hurdles and 300m hurdles events.

'I spent 3 years coaching him at the Pietermaritzburg University hockey club and here too he played a major role in three very successful seasons for the students. I was fortunate enough to have him as a very important member of the Natal men's hockey team that I coached in 1992.

'In winning the Allied Cup and Allied Shield trophies in the same season, Rhodes played a significant role and South African hockey was always going to be poorer off for his not being able to fit the hockey time into an increasingly demanding cricket schedule that would see him make a major impact at the World Cup that same year.'

Playing beach cricket in Ramsgate, Natal South Coast, age 6.

Your Country
Needs You

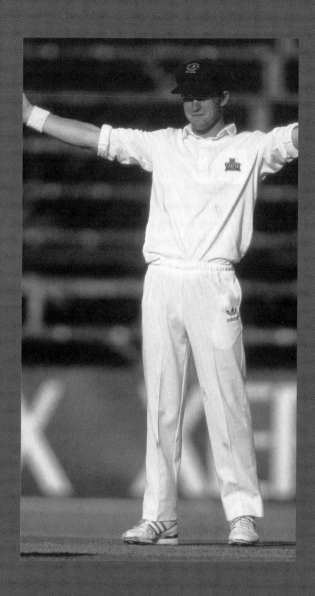

Jonty – In Pictures

There was an initial squad of 20 that I was in, but I never believed that I would actually go to the World Cup. My average wasn't great and I felt that I would have to make it as a batsman, never thinking that my fielding would be such an asset. But I watched the three matches against India on television and I knew that the selectors were looking for a few younger guys because the Indians out-fielded the South Africans.

On the day of the final announcement I was playing a league game at Dalry Park in Pietermaritzburg. At the tea interval we gathered around the radio and I thought that if Peter Kirsten was in the squad it would probably be at my expense. The announcer went through the list alphabetically. Peter was in and I thought that was me gone, but I listened on and then he said, 'Dave Richardson'.

Right: *He's got the whole world in his hands. Jonty at the Wanderers looking after anything that goes in front of square.*

Below: *Sweeping to victory. On our way to an important win against the West Indies in Christchurch, New Zealand. We got 200-8 on a slow pitch and bowled them out for 136.*

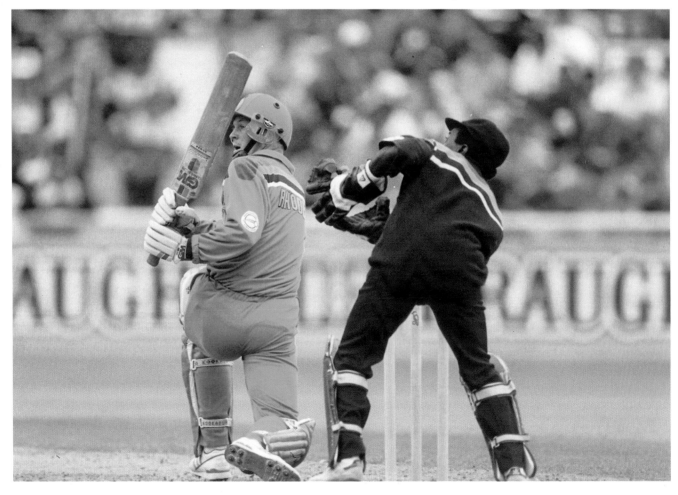

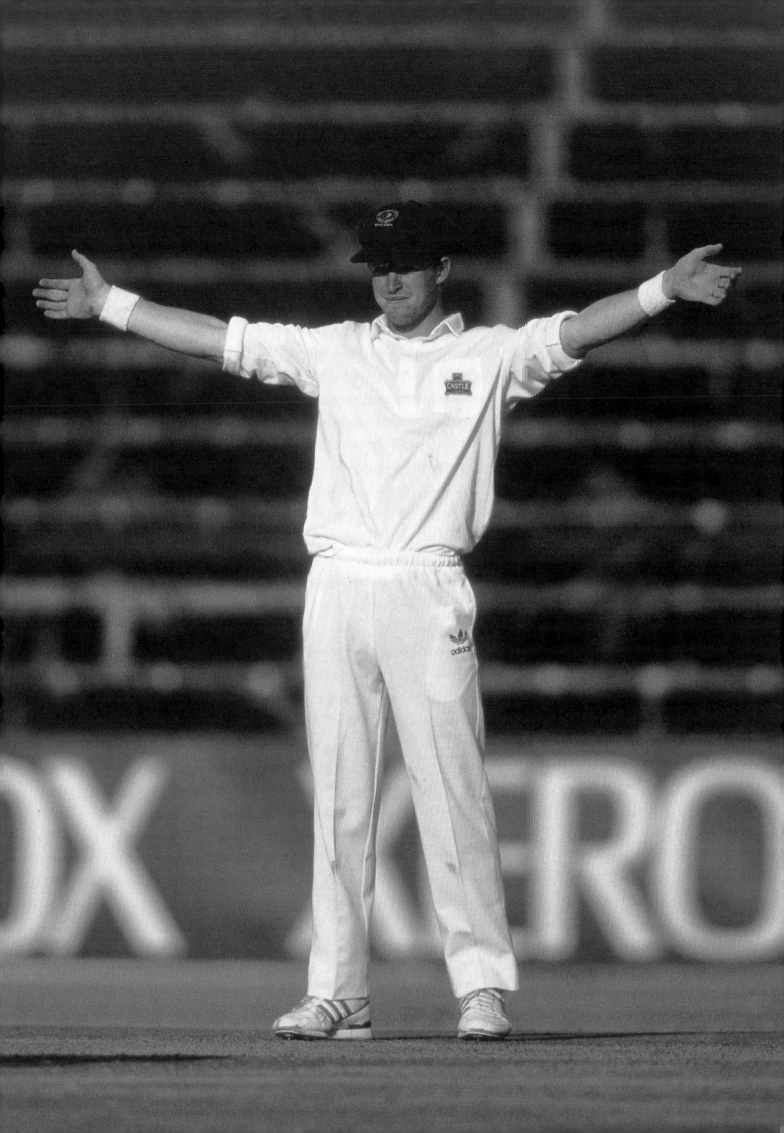

Now, if you go through the alphabet 'h' comes before 'i', so I thought, well that's definitely me gone, and then he said my name and I dropped the can of Coke I was holding. I had never been abroad before. The first stamp in my passport was to go to Australia to play in the World Cup. It was such an eye-opener: Peter Kirsten was 32, I was 22 and we had the same experience of international cricket!

When we got there we were so absorbed in the experience that we forgot what was going on in South Africa. We woke up when Ali Bacher came out and said that if there was a 'No' vote in the referendum we were all going home. (The vote was on whether to allow the reforms that were under way to continue and to allow the ANC to join the government.)

There was no strain in the squad; we were unanimously in favour of the 'Yes' vote. We understood that it was the only way for South Africa to go forward. But more than that, we had such

Top right: **Teasing Ajay Jadeja in the Test match against India at the Wanderers in 1992. He asked if I was going to dive on his stumps as I had with Inzamam. This is me on the runway.**

Bottom right: **Practising with Kepler Wessels at the Plascon Academy. Kepler was the only South African at the World Cup with experience at international level.**

Below: **Bowling to Ajay Jadeja at Newlands, 1993.**

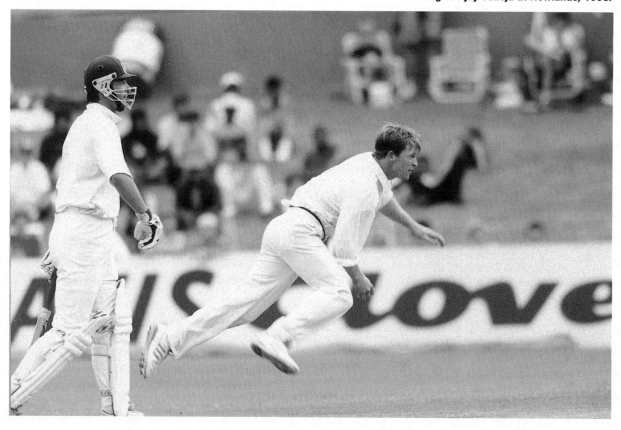

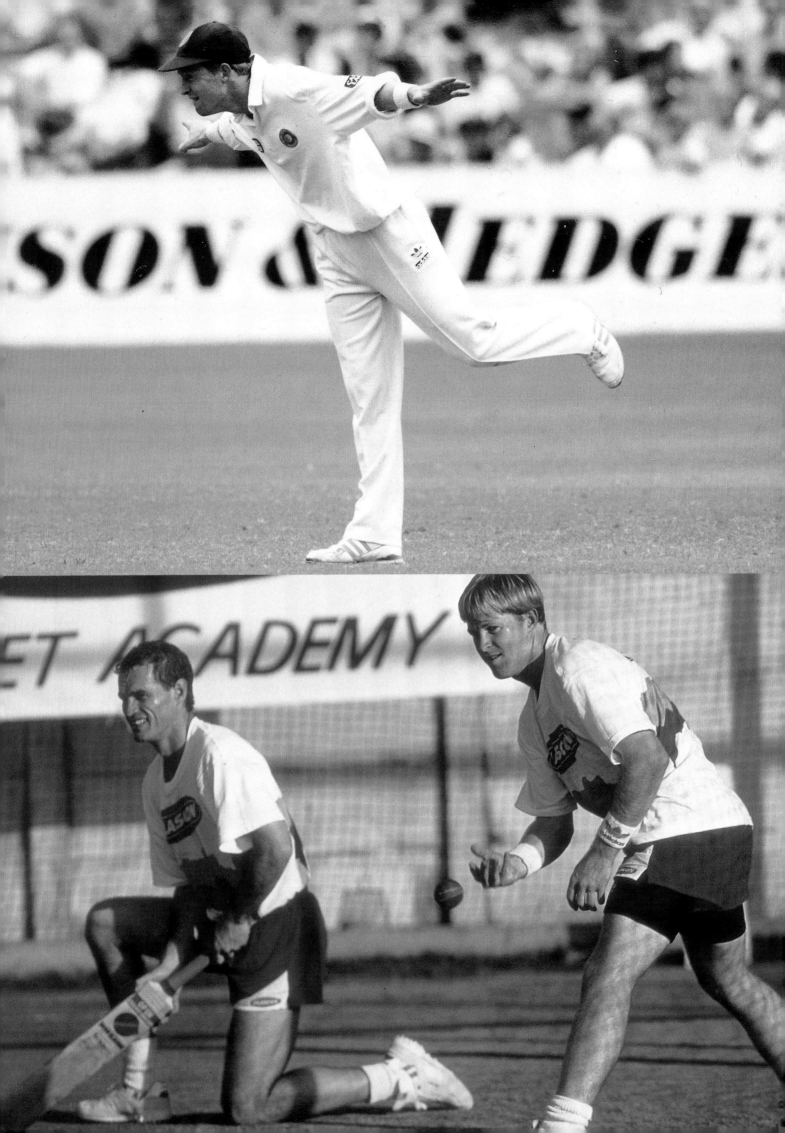

Your Country
Needs You

a reception in Australia, people were so glad to have us back, that we began to understand for the first time what isolation had really meant.

South Africa had been a pariah state and only on my first trip abroad did I really understand the public perception. And now people were so chuffed about what was happening in our country that it very quickly became clear to the squad that it wasn't really about how we played, but how South Africa went forward from here that mattered.

The Picture That
Launched A
Thousand Haircuts

The Picture That Launched A Thousand Haircuts

It was still the league section of the World Cup. We batted first and got just over 220, which wasn't a very competitive total. We bowled well up front and then it rained and in those days the rain rule really favoured the side bowling second. When we came back out Pakistan needed 120 off 14.3 overs, the best part of eight and a half an over.

Imran Khan and Inzamam played so well that they were getting them easily from the first six or seven. There had been a huge downpour and the outfield and the ball were both wet. Our bowlers were struggling to grip the ball properly and we were rapidly losing the game. There were lots of boundaries because we were bowling full tosses in a failed attempt to bowl yorkers.

I was standing at point on the edge of the 30-metre circle, because we were happy at that stage to give away ones in an attempt to stop the fours. Brian McMillan was bowling and he hit Inzamam on the pad. I've seen the replay and it should probably have been given out, but it wasn't.

I ran in and picked up the ball about halfway between the edge of the circle and the stumps. Inzamam's a big guy and I thought he was never going to get back; so I decided not to throw, but to run in and break the stumps. He actually surprised me because he got back a lot quicker than I was expecting.

Now remember that this was before the third umpire system came in so the decision had to be given by Steve Bucknor from his position at square-leg. Looking back at it now it was a brave call, even though it was the right one, because without the benefit of watching it on the TV replay it's the kind of judgement that used to be given to the batsman as benefit of the doubt.

But it was given and it proved to be the turning point of the game. Two balls later Imran was caught behind and the game was as good as won.

The next day we were leaving Brisbane to fly to our next game and there was my picture on the front page of the local newspaper. I spoke to the editor of the paper

and he told me that the photographer phoned him as soon as it happened and said, 'Hold whatever you're doing, I've got the front page picture.'

He hadn't even developed it and he had to find a tickey box to call his editor because that was before everyone had cell-phones, but he knew he'd got an outstanding shot. He was shooting in black and white, but there is a colour one taken by another photographer from a different angle; however it doesn't capture the moment half as well.

The other Australian papers all picked it up and I thought it was a great picture, but that was all. I didn't think I'd done anything special. I didn't realise what an effect that one run-out had until I got home and went for my first haircut. My barber said to me, 'You won't believe how many people have been in here asking for a Jonty Rhodes haircut.'

Overleaf: *Imran Khan is urging Inzamam-ul-Haq to run faster, but I beat him to it. The picture that sent South Africans to the barbers for Jonty haircuts.* Photograph courtesy of the Courier Mail, Brisbane, Australia.

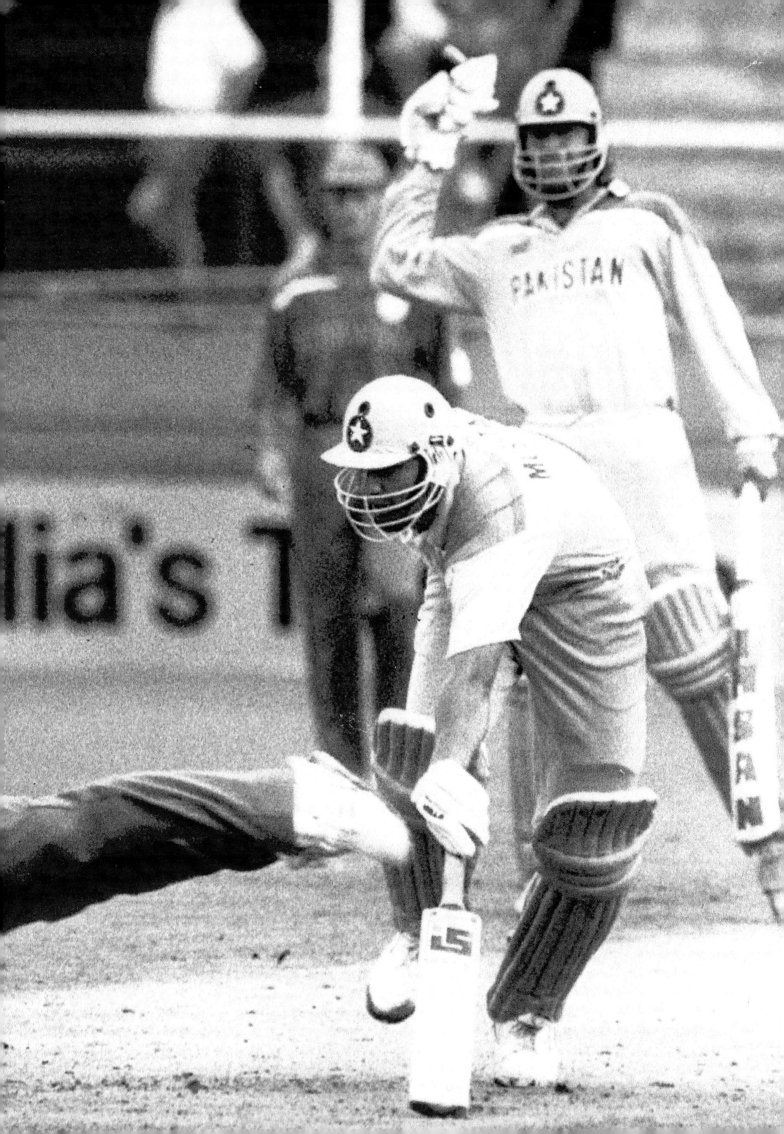

Hitting
(And Missing)
The Stumps

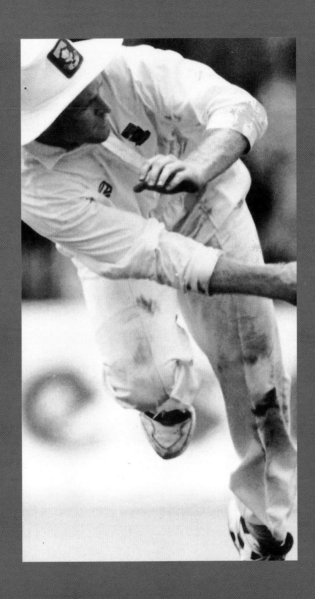

Hitting (And Missing) The Stumps

Jonty – In Pictures

I get criticised for missing the stumps, but it doesn't get to me. I firmly believe that I'm in the team as a fielder to save runs. If I get a few catches and run-outs along the way it's a bonus. I'm there to put doubt in the batsman's mind and, especially in one-day cricket, one run can make a difference. That was our motto for the 1999 World Cup and it certainly proved valid in the semi-final against Australia!

I've always regarded myself as a stopper, but throughout my career people have compared me to Colin Bland. Now I feel really privileged to have people talking about us in the same breath, because from what I've heard he never missed the stumps and could even pick off, middle or leg to hit. But in reality I see myself as a totally different kind of fielder to Colin: I'm a grubby fielder who gets stuck in, but my main job is to stop runs.

Mucky pup. I've applied to the United Cricket Board for an extra laundry allowance. Unfortunately they turned me down.

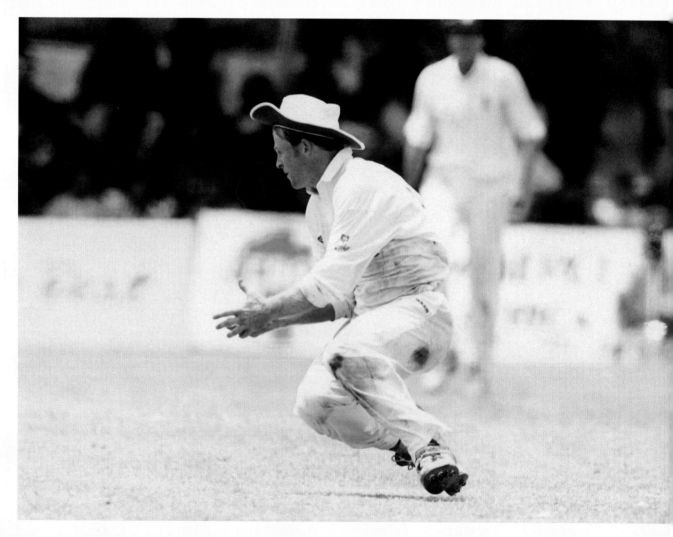

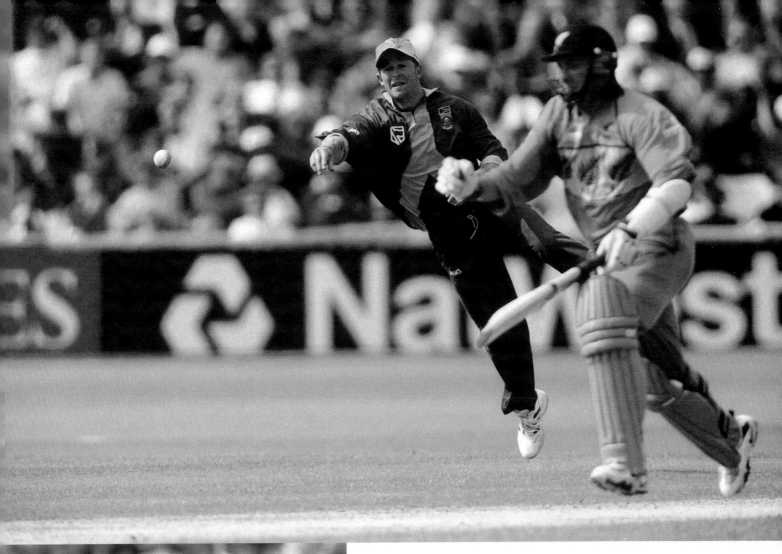

Above: *Missed again. I've got New Zealand batsman Craig McMillan on toast and he's virtually given up. A case where Bob Woolmer's extra step might have paid off, but I'll get him next time.*

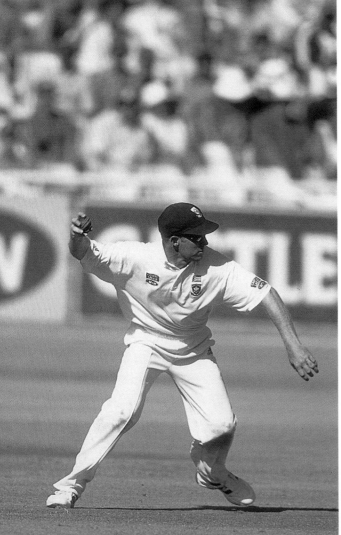

Overleaf: *Attempting a run-out against England at St George's Park, December 1996, Paul Adams' first Test match. I'm well balanced, even though I've only got one toe on the ground. This is likely to be on target.*

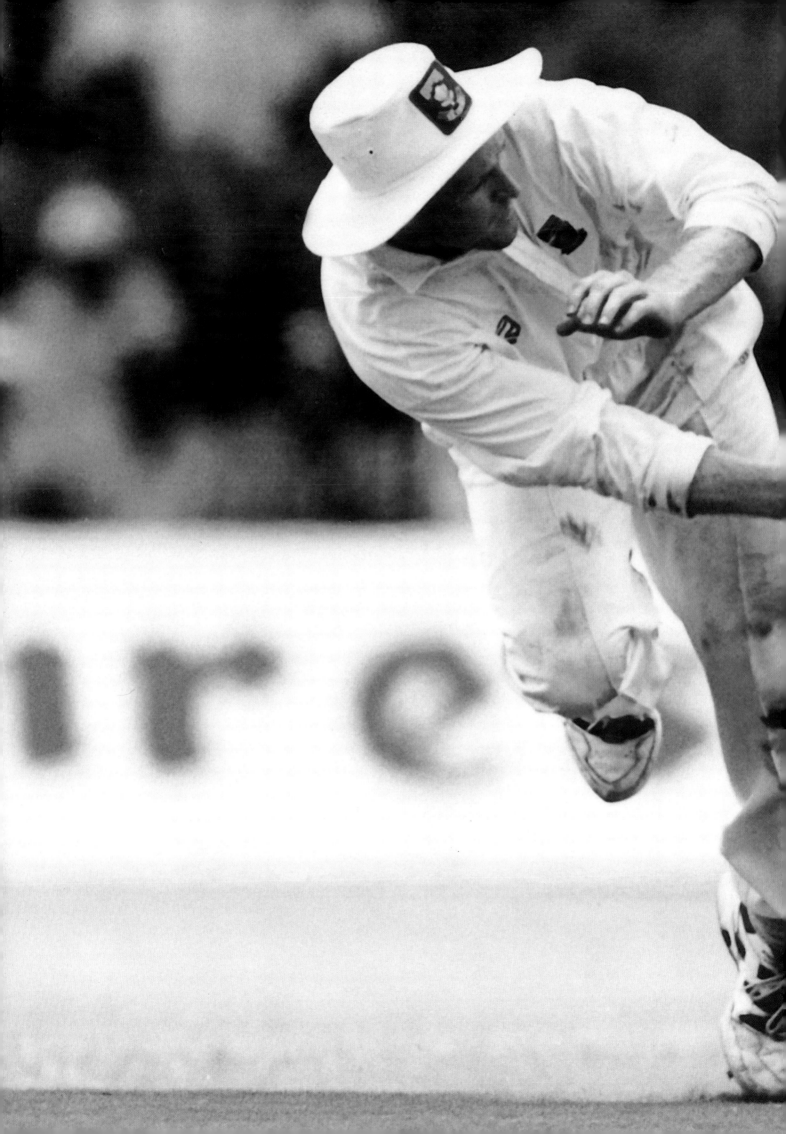

Hitting (And Missing) The Stumps

Jonty – In Pictures

Colin could pick a spot and hit it, but I find that I have more success if I don't have to aim! Sometimes if I'm running away from the stumps and I have to throw the ball under my body I'll hit the stumps because I'm putting it into an area, and obviously we do practise that kind of thing a lot. But other times when you have all three stumps to aim at and there's time to think, that's often when I miss.

The biggest problem with cricket, whether you're batting or fielding, is usually when you have time to think. If you leave it to your instincts you'll normally do a lot better.

There is a lot of technique involved in throwing successfully and I think that's where Colin Bland was the master. The key to it all is good balance and from the pictures I've seen and the film footage, Colin was always balanced when he shied.

Again, I'm very different because I'm often stopping the ball on my knees, or I'm still on the run. Bob Woolmer tried to get me to take an extra step before releasing the ball, but I've found that very hard to do. It felt very ungainly, like I was throwing left-handed.

When I was growing up you had to run a guy out by six inches to a foot in order for the umpire not to give the benefit of the doubt to the batsman.

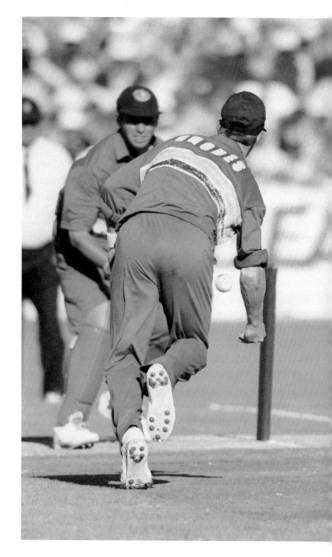

Right: *It might look like I've missed the stumps again, but actually I'm just lobbing the ball to Dave Richardson at St George's Park. Against Australia 1993/94.*

26

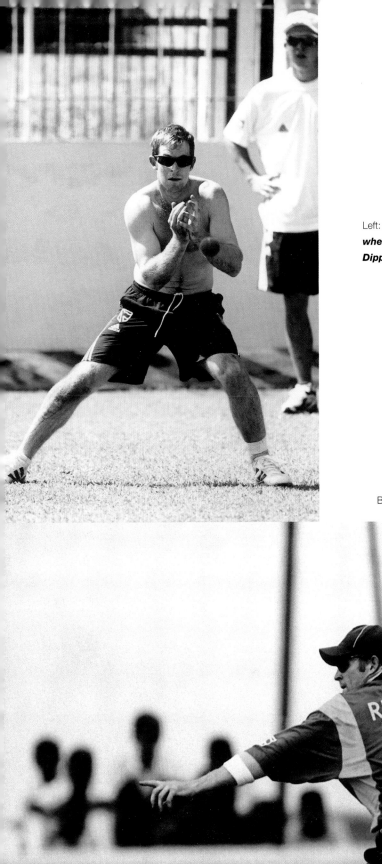

Left: *Typical practice wear in Colombo where it's very hot and very humid. Boeta Dippenaar looks on.*

Below: *A threatening pose, but don't forget the ball! Colombo, 2000.*

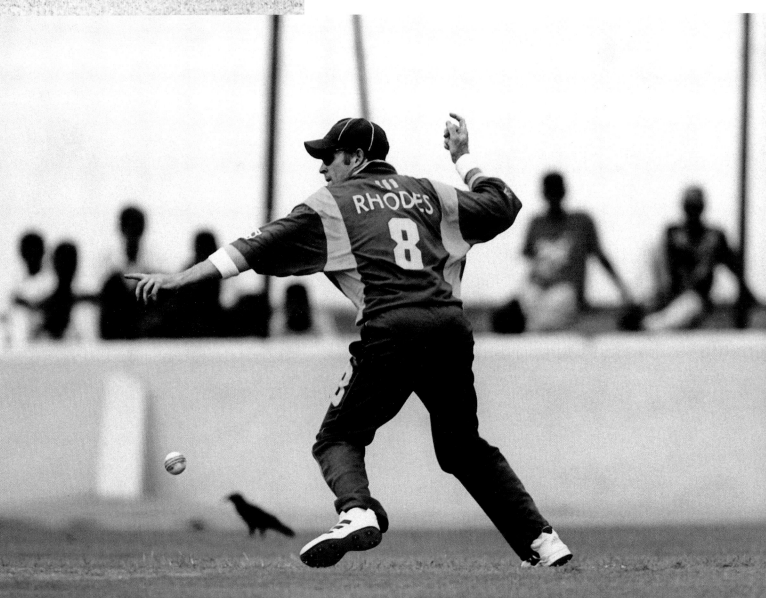

Hitting (And Missing) The Stumps

Jonty – In Pictures

Now with the third umpire in place the guy can be a centimetre short and he's still out, but in the field I'm still trying to do everything as quickly as possible despite the fact that I do have a little extra time.

The best in my time at hitting the stumps has been Derek Crookes. When we played together for Natal we called him 'Dead-Eye Derek'. He would hit three times out of four in a match situation, which is really an astonishing ratio.

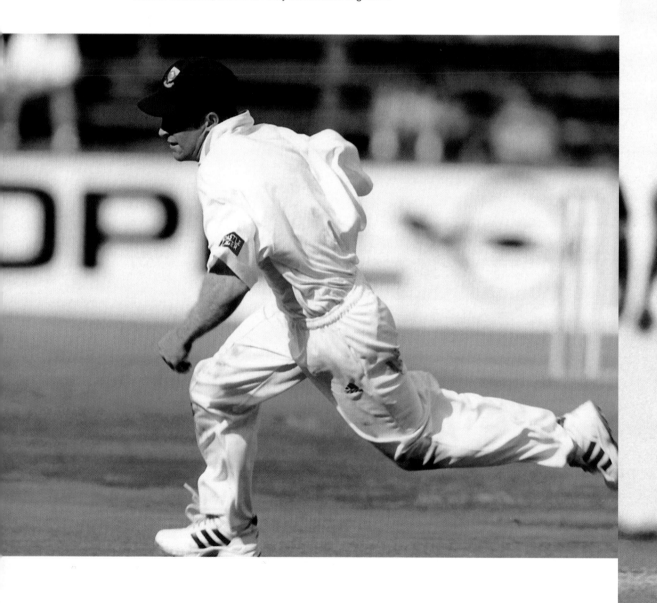

Flight Jonty 818 coming in to land. One of the perils of fielding where I do is that I frequently have to slide on old pitches that are like concrete. In this picture, taken in Sri Lanka in 2000, you can see the bandage on my left arm, put there to protect an old grass burn injury. But at the end of this dive I've probably got a new one anyway.

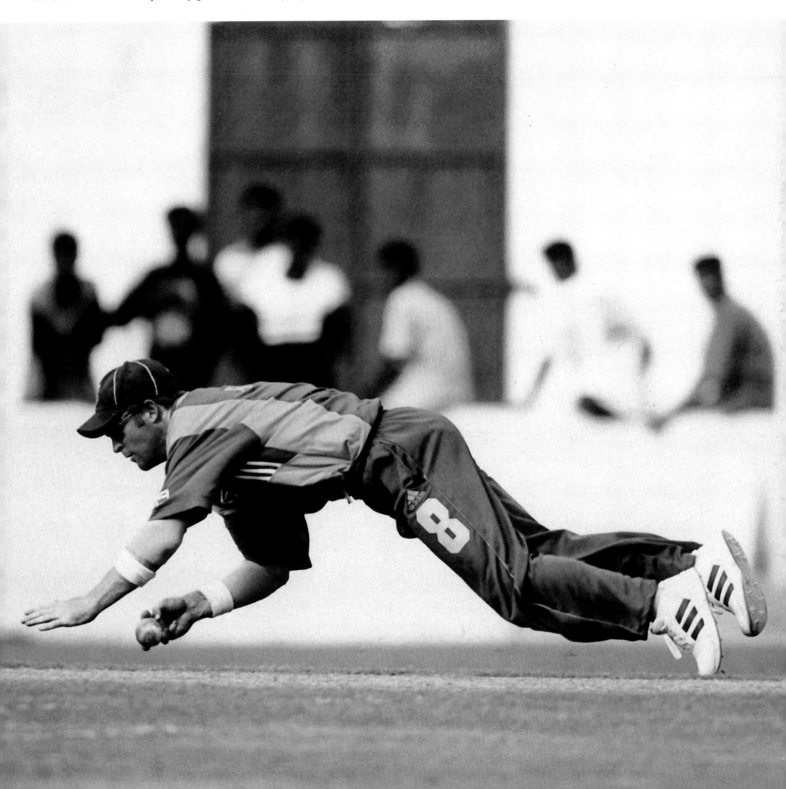

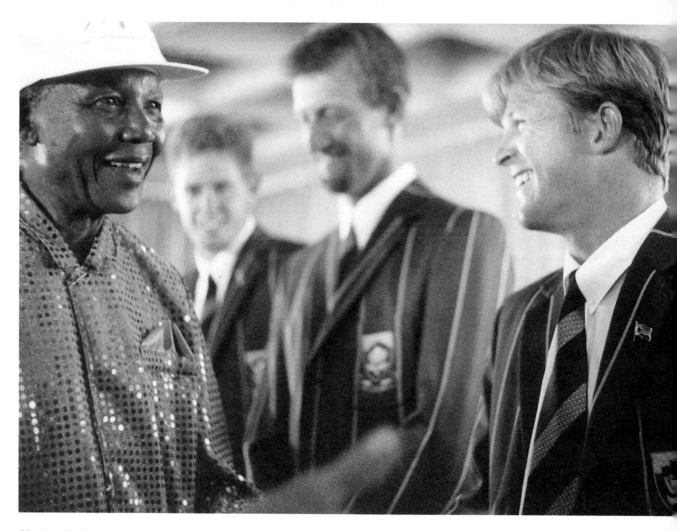

Meeting Madiba. President Mandela wanted to meet us after we came back from the 1996 World Cup. This picture was taken at an airbase in Cape Town. We were playing a Test match at Newlands, but he couldn't get there so we went to him.

Fanie On Jonty

When I was in matric I could throw a cricket ball the length of a rugby field, clearing the poles at both ends. One day I was with some other boys in our squadron and I saw a dove on the far set of rugby posts. It was right at the end of my range, but I said, 'Watch this boys, I'm going to hit that bird', and I did. I promise you I was God in that school for about a year and they called me 'Torrie'.

A lot of bowlers lose heart because of bad deliveries, but when Jonty's around you can afford to bowl bad balls. More than that, when he's in the covers you can change your bowling strategy. You can bowl wide, full balls that might in other circumstances be hit for four, knowing that Jonty is covering a couple more metres than anyone else and that if the batsman tries to chase him away he might nick one to the slips. So he isn't just saving runs, he's helping you take wickets as well.

He helps a lot of people to better their abilities. You reach a certain level and you think you can't get better. But if you see the hard work that Jonty puts in you realise that you're there because you're good and you can get better if you do the same as him.

The first time I really got to know Jonty was on the tour of Sri Lanka in 1993. There were a few of us sitting on the pavilion steps watching him train and someone said to me, 'Fanie, this oke's not going to last', and I said, 'I give him six months'. We thought no one could train that hard and last.

Well, what happened was that within six months we were all training as hard as Jonty! We felt uncomfortable watching him whiz around. We had already had a beer after training and he was still out there doing more. The consequence was that the side came together with a great spirit and we became, in my opinion, the best side in the world, not because of the captain, not because of the coach, but because of the work ethic of Jonty Rhodes.

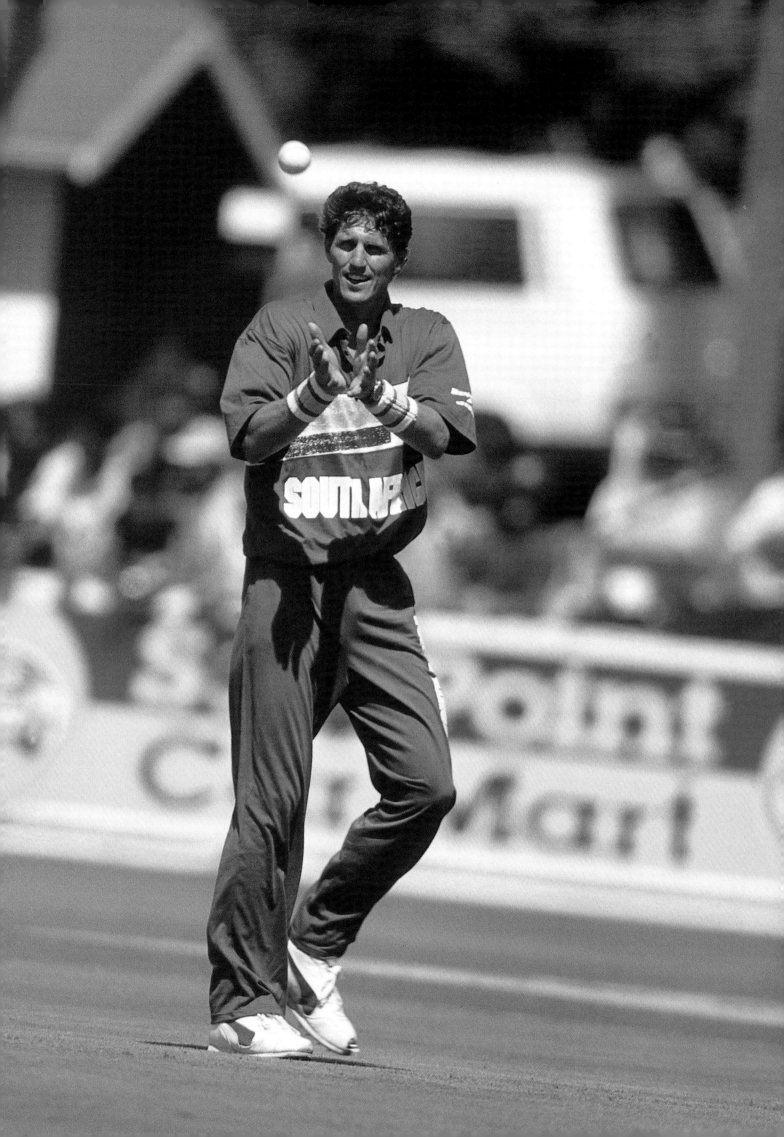

Fanie On
Jonty – In Pictures
Jonty

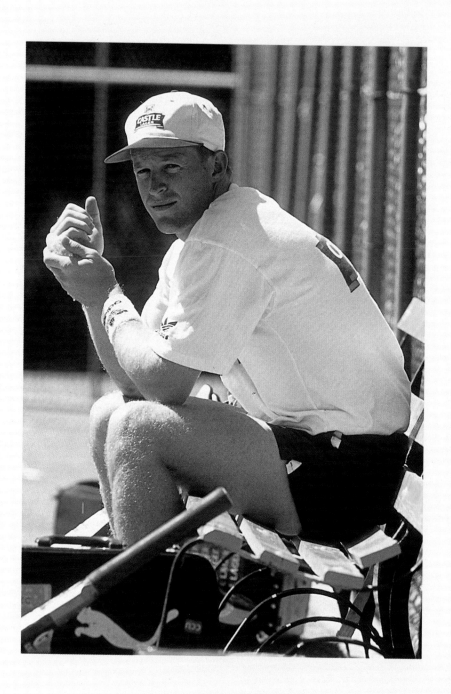

The Man For
Atlanta

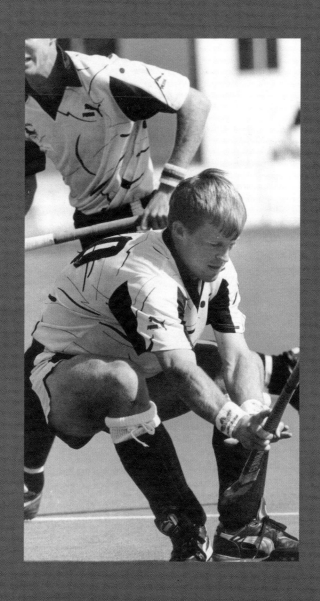

The Man
Jonty – In Pictures
For Atlanta

This picture was taken at the World Cup in 1996. You weren't allowed to practise at the ground you were playing on so we went out to one of the gymkhanas in Karachi. We warmed up on a basketball court, practised in the net and ended up on the hockey field, so it was quite an all-round sports day.

It was actually Shaun Pollock who got me there. Polly's like a little kid who can't sit still for a minute. He saw them practising out there on the Astroturf – I'd be too embarrassed to walk over and ask to borrow a stick, but Shaun loves to get involved. He took a few short corners to show them his power and I was happy to run around with the thirteen-year-olds. I was a bit rusty so that was about my level!

My last interprovincial hockey tournament was in 1992. In 1993 I was asked if I'd make myself available for the national side, but by then I'd been playing cricket for South Africa for a year and was looking forward to going to Sri Lanka in August.

In my first year at high school I thought that I'd go further in hockey than I would in cricket. I was fairly unorthodox – my cricket and my hockey are similar to that extent. I didn't have good stick work, but I was quick to get into space and I did the unexpected.

When I was at school my coach for both hockey and cricket was Mike Bechet. When I was in standard seven he put me in the hockey first team, which caused a bit of an uproar at the school. They said I wasn't big enough and that they weren't responsible if I got killed, but Mike stood by his decision and as a result I played four years of first team hockey.

'I shall always wonder how the twin strike force of an experienced Rhodes and a newcomer in Greg Nicol might have seen South African Hockey fortunes improve had Rhodes been able to pursue his hockey career' - Mike Bechet, Jonty's hockey and cricket coach at Maritzburg College, and the man who tried to persuade him to play hockey for South Africa at the 1996 Olympic Games in Atlanta.

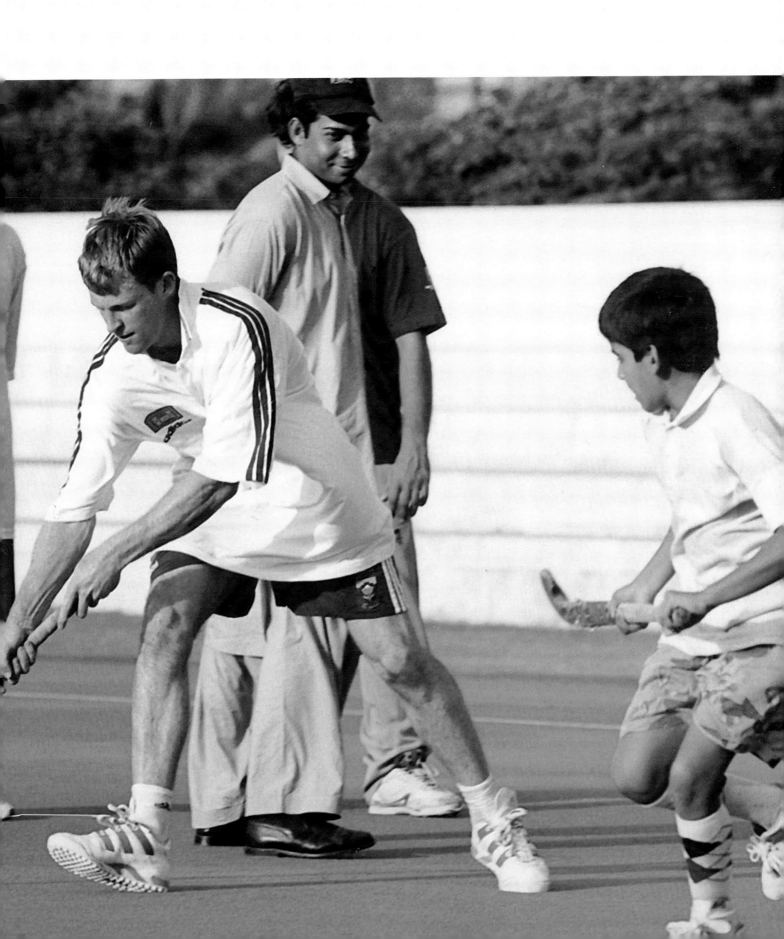

The Man
Jonty – In Pictures
For Atlanta

Mike became the Natal hockey coach and he was really my mentor. Anyway, after the 1996 World Cup I was holidaying at the Fish River Sun with my wife and Hansie and Bertha Cronje. Mike Bechet tracked me down on the phone and by then he was a selector for the national side.

He said to me, 'Look, we're playing good hockey, but we're just not scoring goals. Would you be prepared to come to a trial and play in Atlanta in the Olympics?'

Fortunately I had just pulled a hamstring and I think that saved me from a bit of an embarrassment, because I hadn't played for two years. Also I don't think my wife would have been too impressed because it was the first down time we'd had since 1992. But Kate and I had planned a holiday a year in advance and we ended up in Atlanta anyway, watching the guys instead of playing.

Right: *Playing interprovincial hockey for Natal. Charles Teversham is in the background.*

Below: *Scoring for Natal against Natal Mynahs (B Side) in the 1991 interprovincial hockey tournament in Durban. (Jonty still holds the record for the fastest goal ever scored at a provincial hockey tournament in South Africa.)*

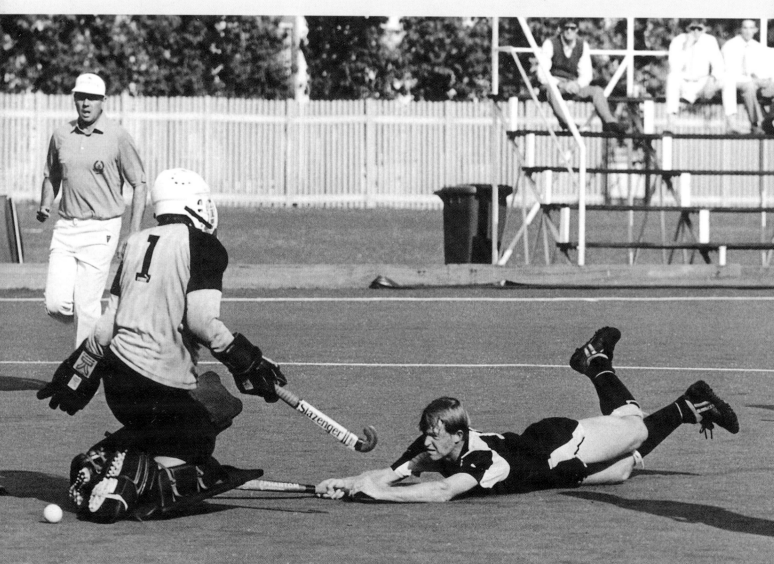

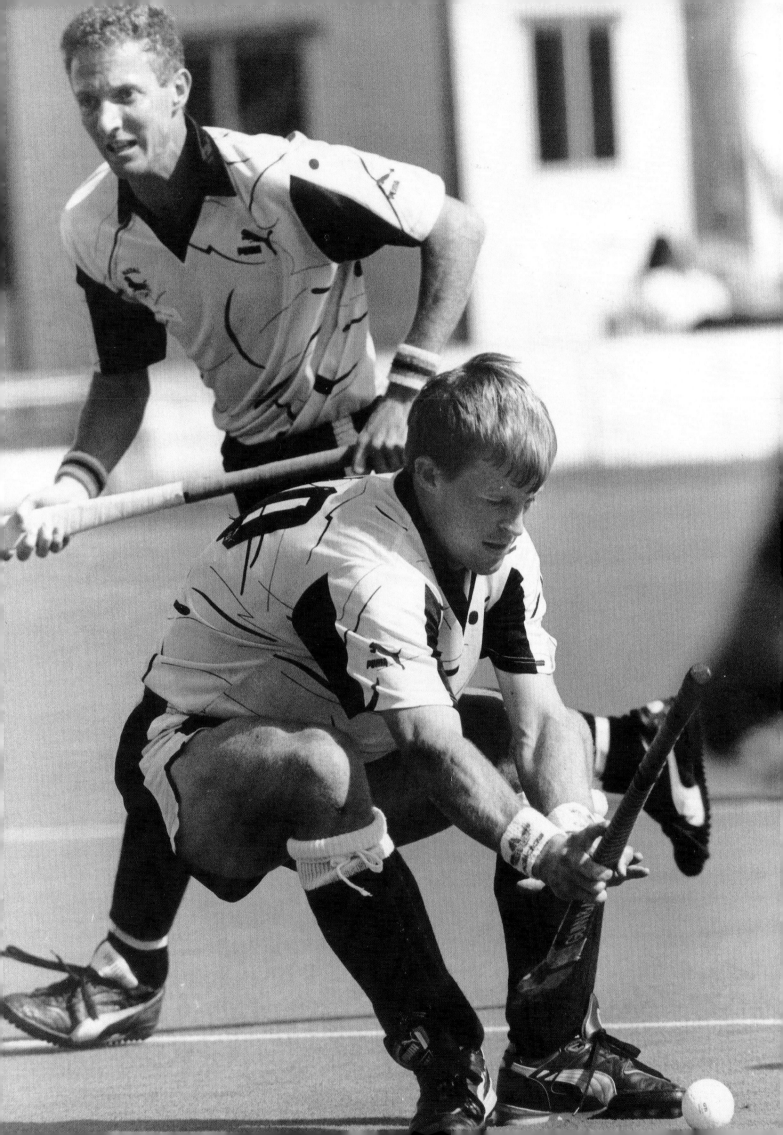

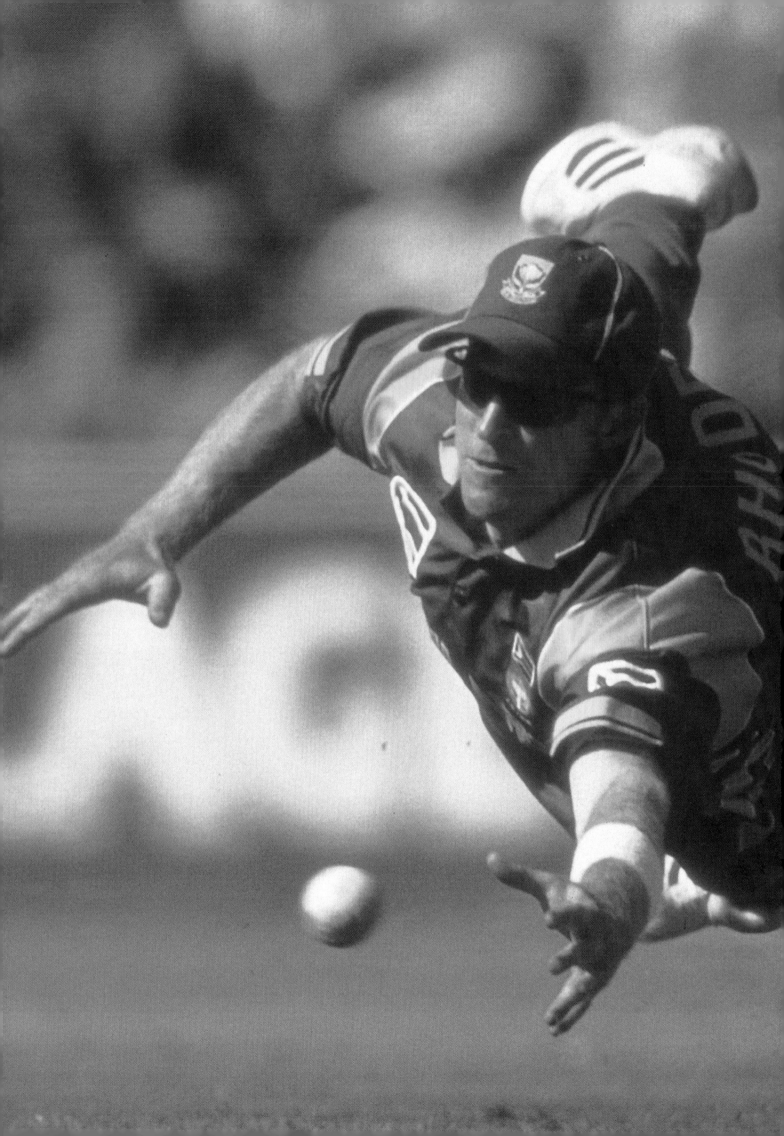

Getting Technical

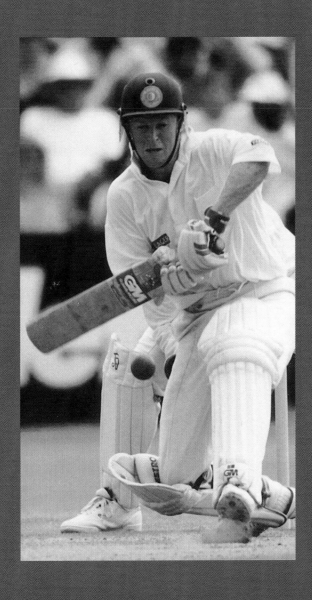

Getting

Jonty – In Pictures
Technical

On a technical basis if you compare pictures taken of me at this stage of my career with those taken at Lord's in 1998 and after, I'm like a totally different player. This picture with my old technique shows how low down the handle my grip is and it's quite possible that I'm actually defending the ball and not playing an attacking shot at all.

In those days I was very bottom handed, but I survived Test cricket for a number of years before they worked me out. The first time I got left out of the Test team was when India toured here in 1996. We had been in India earlier in the year and I pulled a hamstring, which meant that Herschelle Gibbs took my place for the last two Tests.

When India came here South Africa dropped Andrew Hudson down to bat in the middle order and other players were tried there in my stead. Bob Woolmer had been working on my technique since he took over the national coaching job, but we

Right: ***Slogging Reiffel #1**. I hate to tell you this, but although it might look like the start of a cover drive I'm actually about to slog Paul Reiffel over square-leg. The ball is on its way up, not down. I had been using my feet to Reiffel and as a result Adam Gilchrist had come up to the stumps and fine-leg was also up in the ring. So I tried to get inside the line in what is very much a premeditated heave. But because fine-leg was up I knew that if I got a top edge I'd be safe and it worked: I connected well and hit him on to the roof for six!*

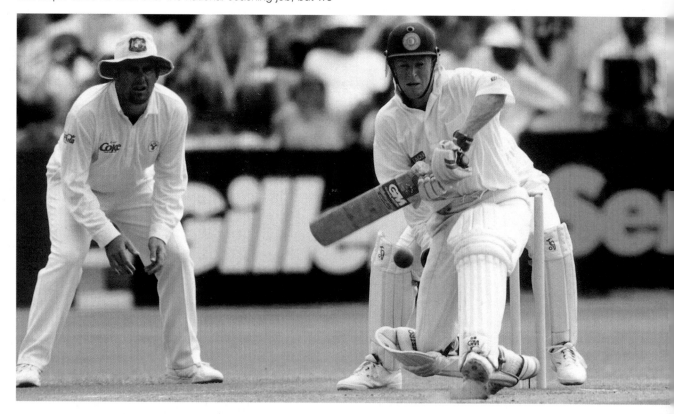

Australian captain Mark Taylor is not impressed by my block sweep against Shane Warne. I probably wanted to play a sweep, but the ball's got too full on me. People say that the worst thing you can do in cricket is to premeditate a shot, but when you're playing a spinner like Shane I find that the sweep is a vital weapon. I've got out doing it once or twice, but I've scored a lot of runs as well. And I'm not necessarily talking about boundaries as much as singles that allow me to get down to the other end.

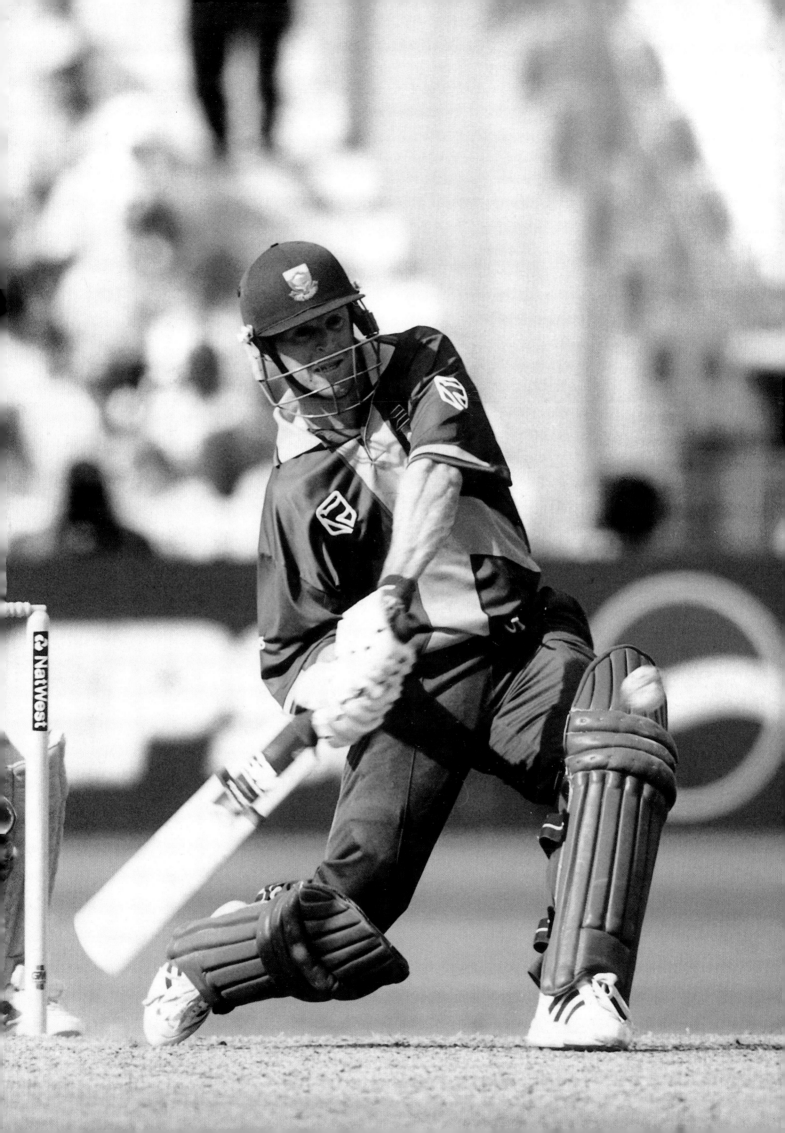

hadn't had an off season since coming back to international cricket and it's very difficult to make major changes while you're involved in an important series.

So being dropped helped me to concentrate on remodelling my game. I was very chest on and bottom handed, which meant that I was getting caught behind a lot. Bob also noticed that I was moving my front foot as the bowler delivered, which meant that my head was moving when it should be stationary.

It was a bad habit that might be traced back to my hockey background where you move towards a moving ball. But it was a habit that actually helped me in one-day cricket where I was on the move and so far down the pitch when I met the ball that

Top right: **Working on technique in trying conditions. This is a typical example of practice facilities in Pakistan. The locals have joined in to help while I face throw downs from Bob Woolmer.**

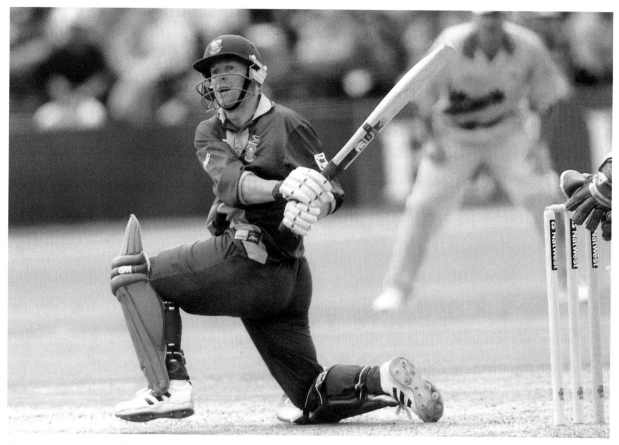

Slogging Reiffel #2. It's nice when a plan comes together. Watching the ball disappear on to the roof and ignoring Australian expletives.

Bottom right: **Keep that bat straight, boy. Using my feet to the New Zealand medium pacers at Newlands in 2000. I'm not trying to hit it for four, just to chip it over the infield in order to rotate the strike. It worked, too.**

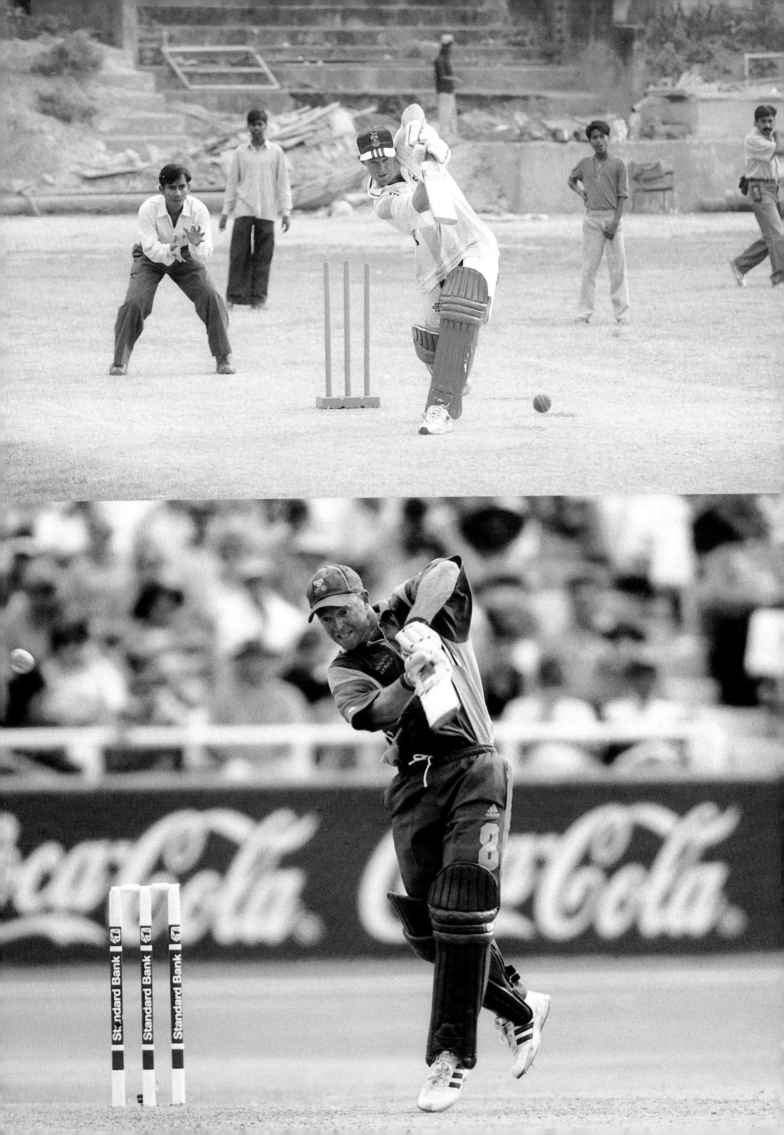

I could often deflect it down to third-man and come back for two.

A lot of the runs I made in one-day cricket were because of my bad technique. If you look at a technically correct player he can sometimes struggle in one-day matches because the fielding captain works him out, sets the field and a lot of the shots

Right: *This is a classic example of where I've improved. My head and my shoulders are over the ball and my hands are following the line of the ball. You'll never see a shot of me like this before 1998 because I'd have been looking to open up my shoulders and whack it to leg.*

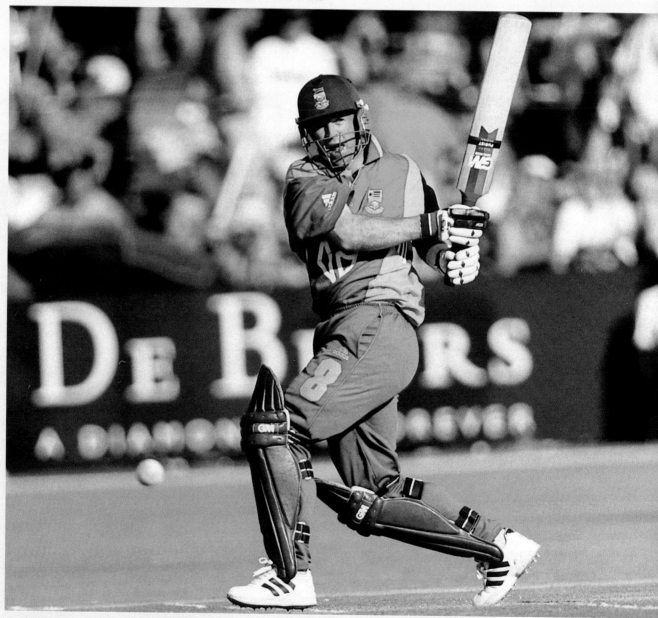

Jonty's a diamond. Pulling off the front foot against New Zealand at the De Beers Oval in Kimberley, 2000. In the dressing room after the game I told my coach Graham Ford that I had decided to retire from Test cricket.

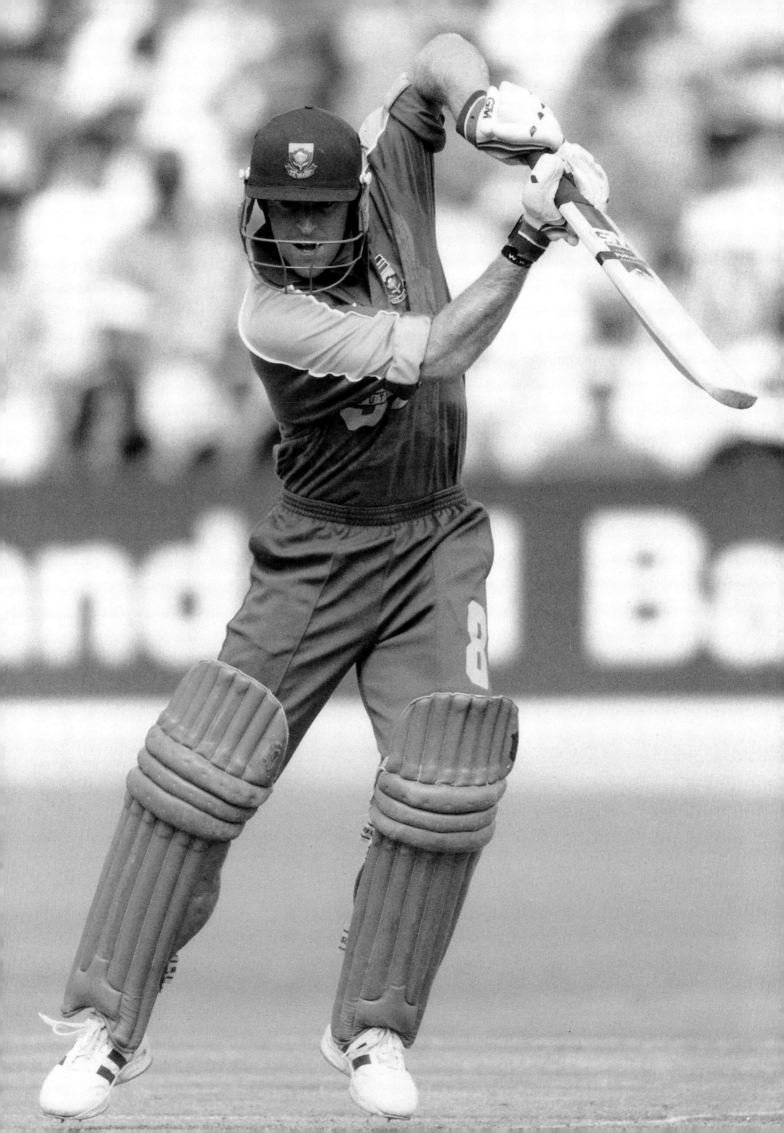

should go straight to fielders. Where I scored was that the ball didn't necessarily go where I was aiming, and it's very difficult to set a field to someone like that.

But it's one thing being on the run when you play in one-day cricket and quite another when you're in a Test match and there are three slips and a gully waiting for the edge. So while it sometimes helps not to have a hundred per cent correct technique, you have to know which balls to hit. Bob discovered that my shot selection was poor.

Right: *This is a front foot pull that I've missed. In one-day cricket you can't just play the orthodox game and being a short bloke I find it's quite an easy shot for me. I can get under a good length ball and pull it. I get teased in the team. They say, 'Well it wasn't quite a half-volley so Jonty pulled it.'*

This is the kind of thing that happens when you need seven an over and you're searching for a boundary because a run a ball isn't going to work any more. You start playing shots against deliveries that aren't in the right place. But I have changed my attitude over the last two seasons and what I try and do now is to be not out at the end.

Even if the run-rate gets up I have to remember Graham Ford's motto, 'Be there. Stay there'. It doesn't usually work when we're batting first because you never really know what a good score is and you're never satisfied with six an over.

But when we're chasing a total and we know what we have to score, even if we have a couple of overs where the rate goes up, the fact is that I'm now an experienced player and if I'm there at the end we'll get there more often than not.

Playing on with a broken hand. I broke it during the one-day series against Australia and New Zealand over Christmas and New Year in 1993/94. The first Test in Melbourne was a rain-affected draw and in our only innings Kepler and I put on a century stand of which I only made 35 not out, mainly because with my broken hand I couldn't hit the ball off the square!

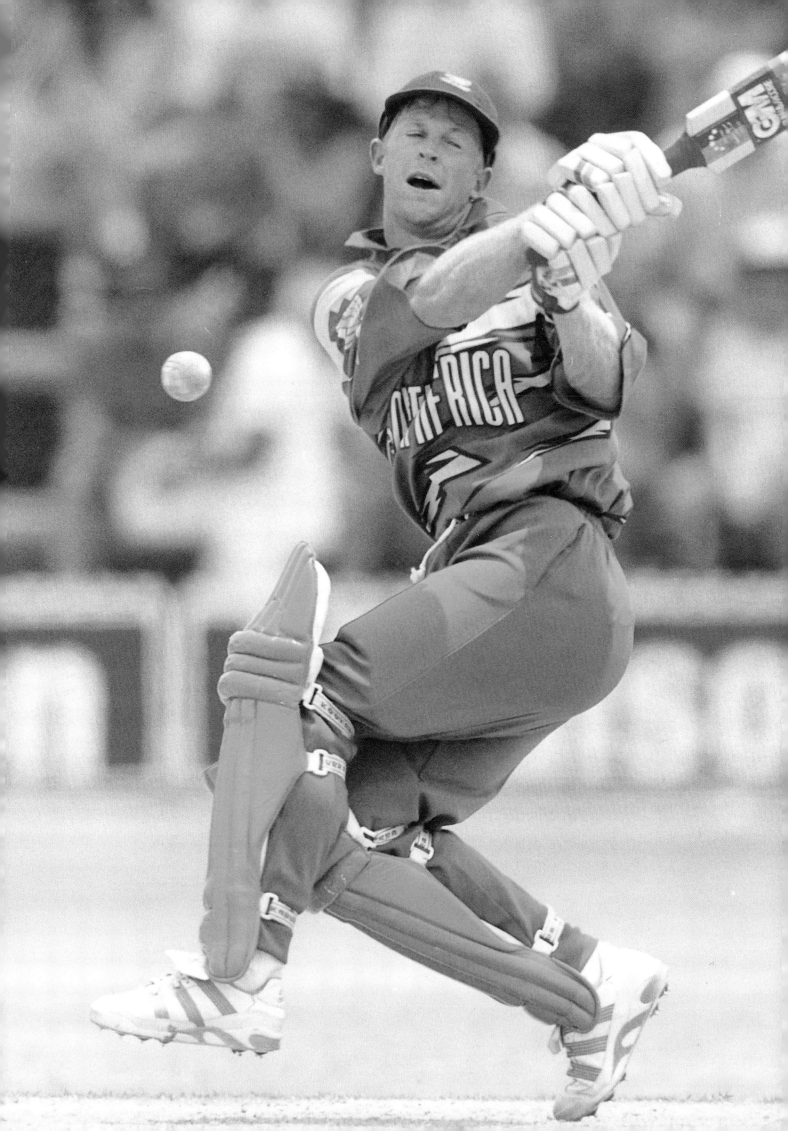

Jonty – In Pictures

I never used to play much off the back foot through the off side. If the ball was short I'd pull it and that got me into trouble because my shoulders opened up. So Bob worked on getting me back and across and using my top hand to play the ball through the covers without cutting.

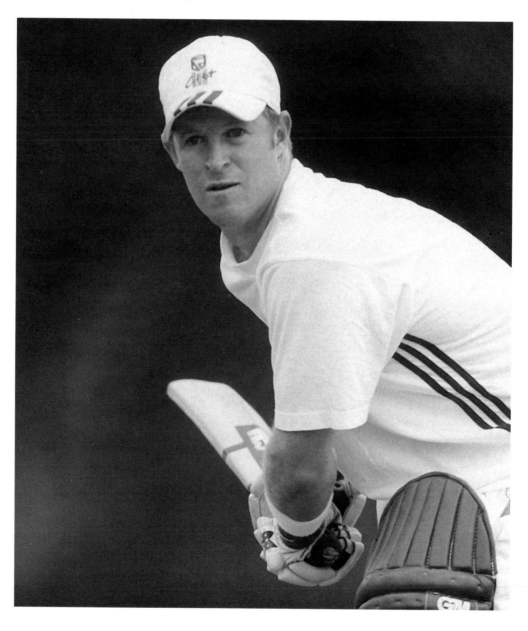

Right: *Up in smoke. Caught on the boundary at St George's Park against the West Indies in 1999. Keith Arthurton was bowling left arm spin and I hit him pretty well. I thought I'd cleared the fence until I saw the boundary fielder was the giant Curtly Ambrose.*

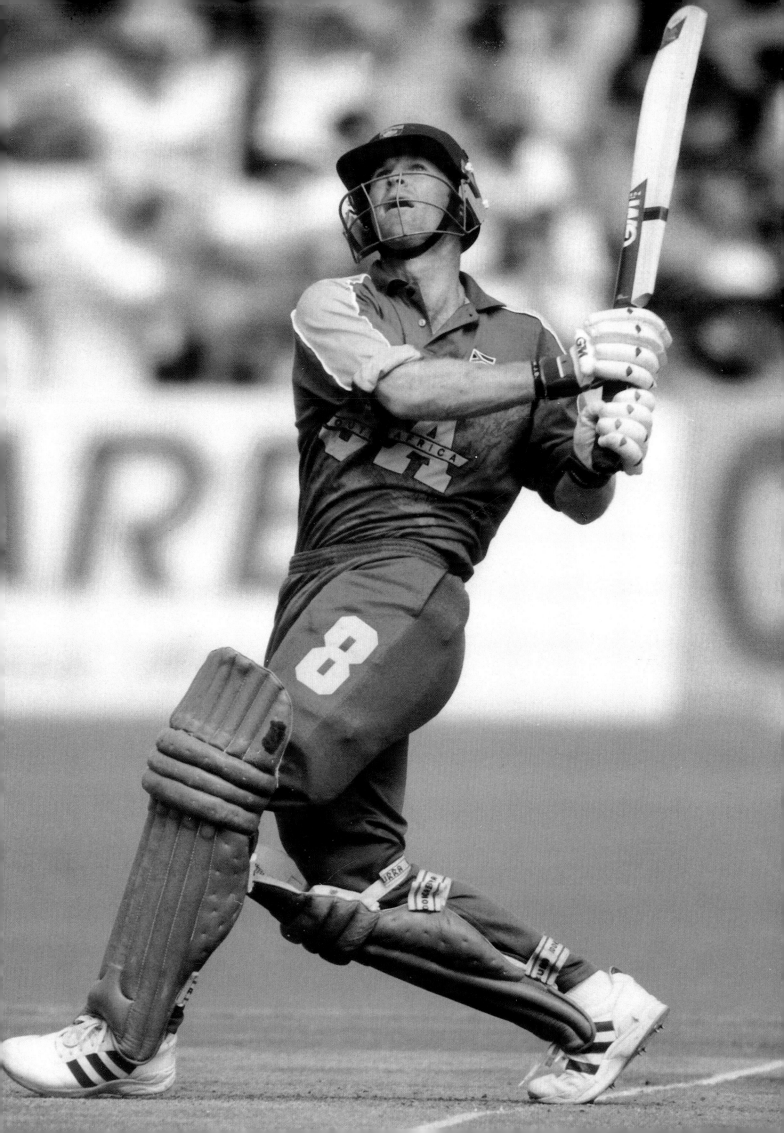

Jonty – In Pictures

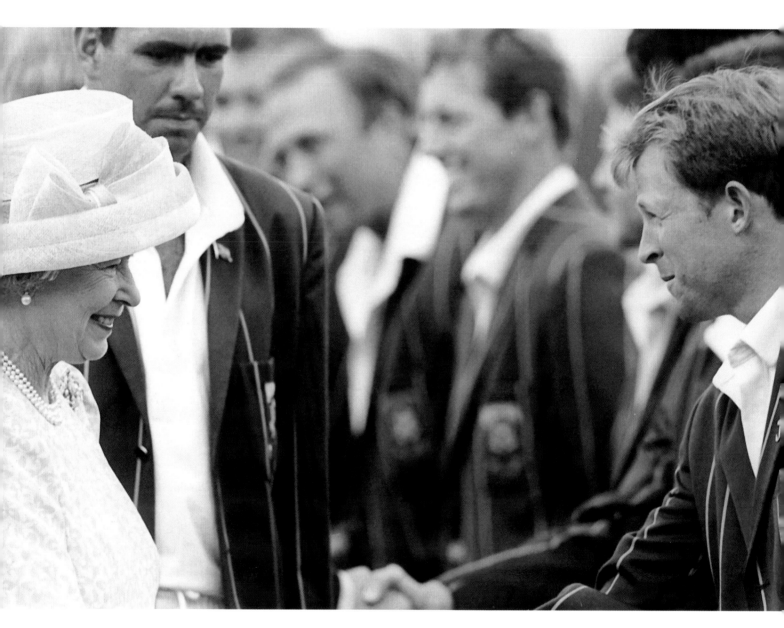

Meeting the Queen. I've met Queen Elizabeth three times in all. Once at Arundel in England in 1994, once on the QE 2 in Durban and this occasion is the most unlikely of the lot: Hansie is introducing me during the break in a Test match against Pakistan in Islamabad.

Boys My Mother
'Warned'
Me About

We've been friends for a long time now and it's not like we remember each other's birthdays or phone each other every week, but when we get together we just pick up where we left off. People are always amazed that we get on because Shane comes across as boorish, arrogant and rude. And of course people have this image of me as the boy next door with the cleaner than clean image and they wonder how it is that we get along.

On the field Shane plays with a lot of heart and as a leg-spinner you can't intimidate batsmen with bouncers like the quick bowlers do so you have to try something else. And Shane has got it. He has this presence that is very intimidating and I admire him for it.

When we were in isolation I didn't have South African sports heroes, because the guys I saw on television were Australians. So on my first tour to Australia in 1993/94 I had to come to terms with playing against the guys that were my cricketing heroes, like the Waugh twins, Allan Border, Ian Healy and Craig McDermott.

During the Sydney Test, the one that Fanie won by bowling Australia out on the last day, Kepler was adamant that we had to go into the Australian dressing room and share a few beers. It was the second or third day of the game and we went in to see them and they were all there, all my heroes and I just didn't feel that I was worthy to talk to them!

But in the corner I saw a big mess on the floor, smoke was spiralling up to the ceiling and there were two empty beer bottles on the floor. This was only half an hour after the close and the guy who had drunk them was obviously hot and bothered after a long day in the field. That was how I got to know Shane.

It turned out we had quite a bit in common. We were both 23, both engaged to be married and he was the only guy I felt I could talk to without being in awe. So we struck up an interesting friendship and the next time I was in Australia he and his wife took me out for a meal and Kate and I reciprocated when he was next in South Africa.

Kate didn't want to go. She'd heard about this bloke, seen him on the pitch and no way was she going out for dinner with him. Well, we were eventually the last to leave the restaurant because we were just having a great chat.

So the point about Shane is that he's a very misunderstood person, but he doesn't do himself any favours. I think he understands that he's his own worst enemy, but he's a generous bloke with a big heart. He's helped Paul Adams as much as he can, I see him talking to spinners from all the other sides and trying to help them.

As a spinner he is a class above everyone else and he has a fabulous Test record to prove it. But if anybody wants to learn he's prepared to give them his time and that's something you don't see very often, because in Test cricket you're always looking over your shoulder worrying about someone who's going to come in and take your place.

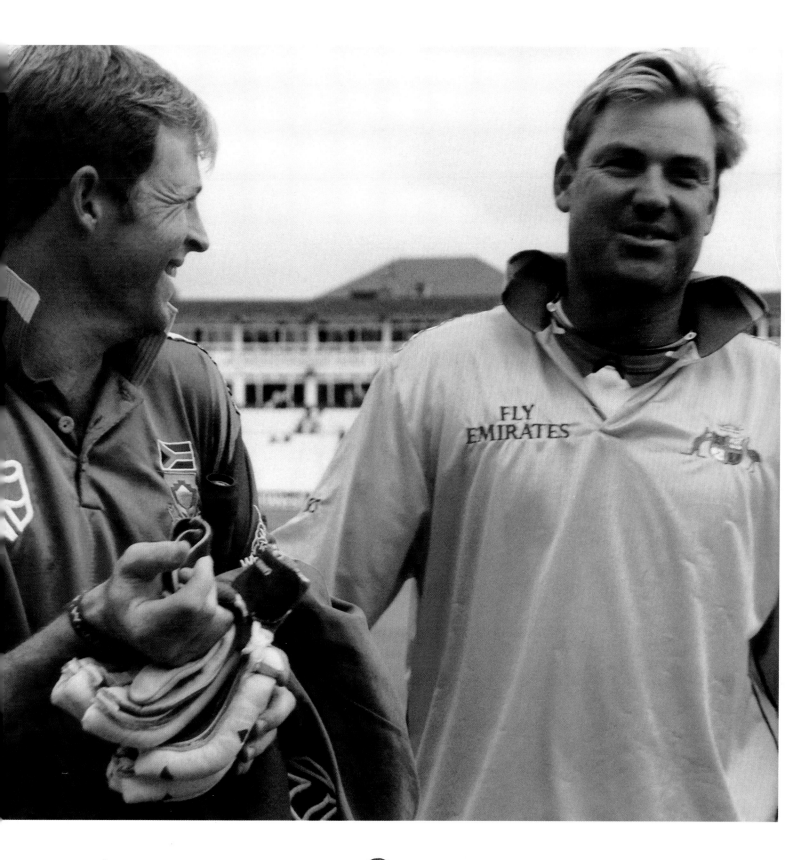

Boys My Mother 'Warned' Me About

Jonty – In Pictures

Rarer than the duck-billed platypus: Jonty bowling. This is a very significant picture because not only was it taken during one of my only two overs in Test cricket, but it also hastened the retirement from the game of the great Allan Border. It was the last day of the third Test and a draw was inevitable. Border battled three hours for 42 not out and I bowled him a maiden. Afterwards he said if he couldn't score a run off me then he better get out while the getting was good. My only other over was against Ajay Jadeja of India at Newlands.

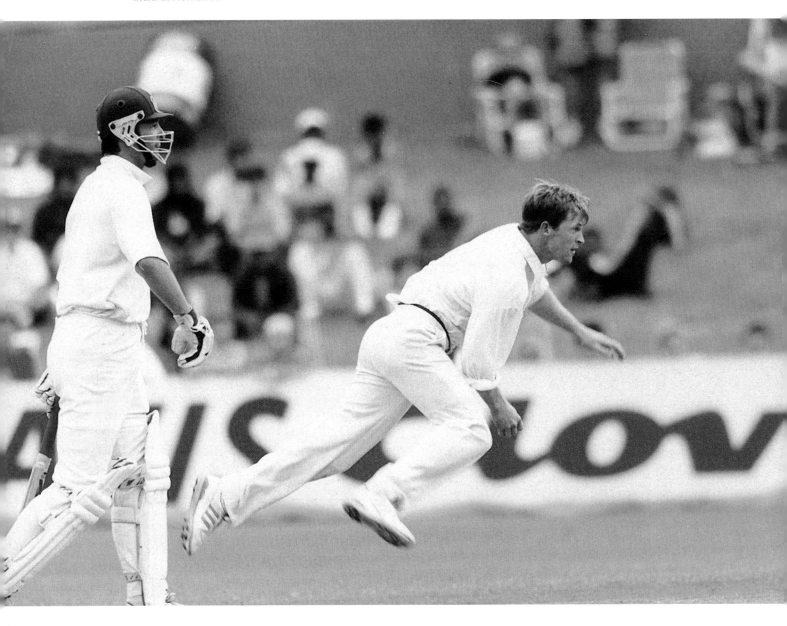

The Jolly
Sweeper

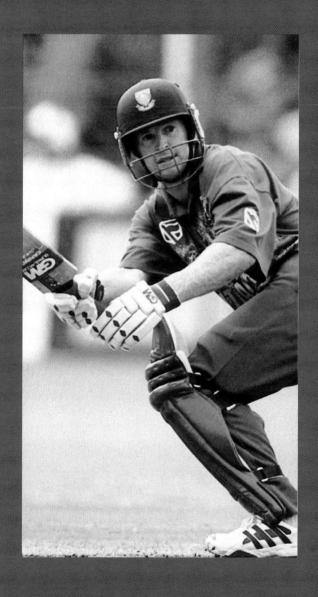

The Jolly
Jonty – In Pictures
Sweeper

For me the sweep is not an aggressive stroke or the risky one that most people assume it is, it's my way of rotating the strike. Most of the time I sweep the ball it's to the boundary fielder for one, or into the gap for two. I'm not looking for a boundary.

The shot that Hansie perfected, the slog sweep, I don't play at all. People wonder why and the reason is that I don't have the power. Because I'm a smaller guy I tend to get under the ball a lot if I try to hit it out of the ground, whereas Hansie, or a guy like Jacques Kallis, can stroke the ball for six.

Right: *In control of the shot. Sweeping for a single against Zimbabwe in Harare, October 1995.*

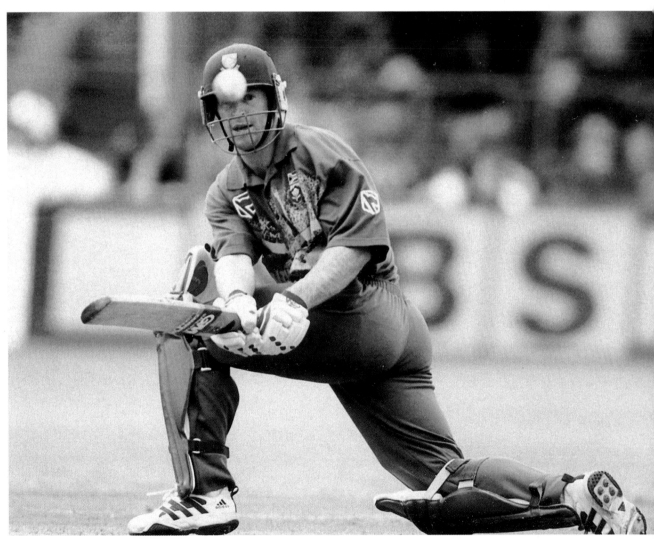

A way of rotating the strike. Against Australia at Kingsmead in 1994. I'm not trying to hit a boundary, just picking up a single to the fielder on the deep backward square boundary.

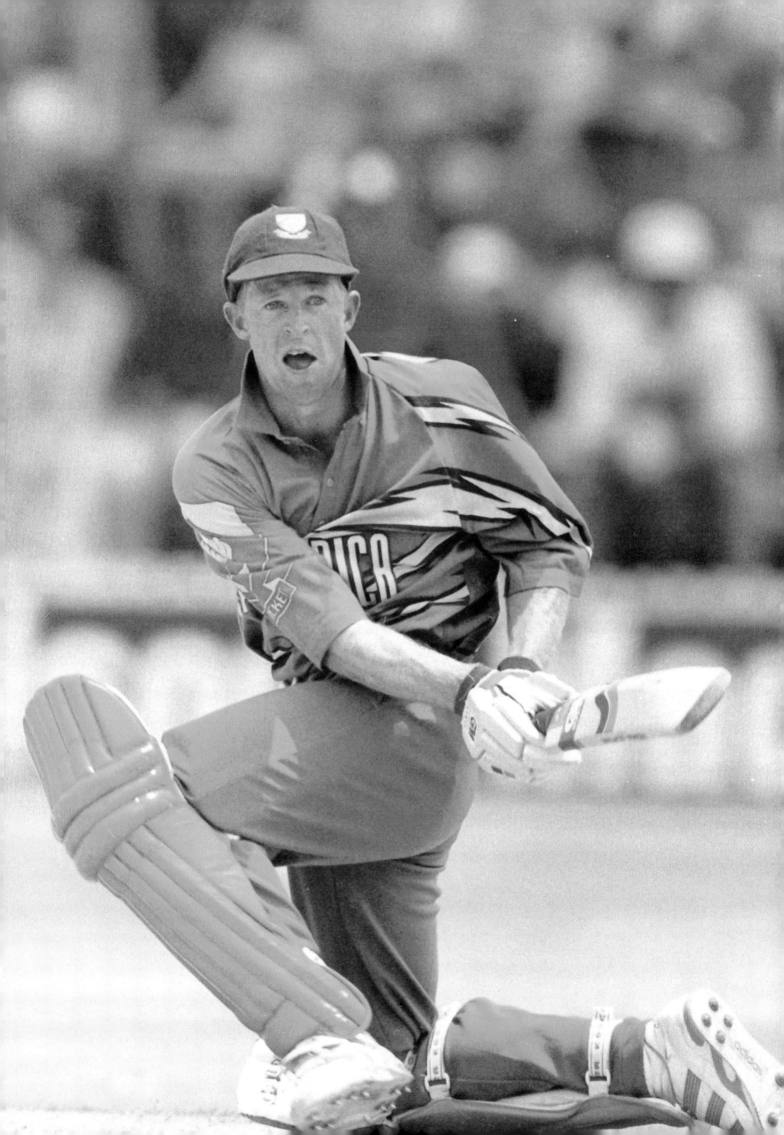

The Jolly
Jonty – In Pictures
Sweeper

So I'm happy sweeping for one and I'd rather do that than try, for instance, to work the leg-spinner to mid-wicket. If I miss the ball it's normally unlucky to be given out lbw and I don't go over towards the off side so I'm never going to be bowled round my legs.

I don't sweep the off-spinner often because it's easier to play the ball into the gaps on the leg side with a straight bat. For me it's more of a shot against the leggie or the left arm spinner. I remember Trevor Quirk having a frothy on air when I swept Shane Warne because it goes against all the old principles to sweep against the spin.

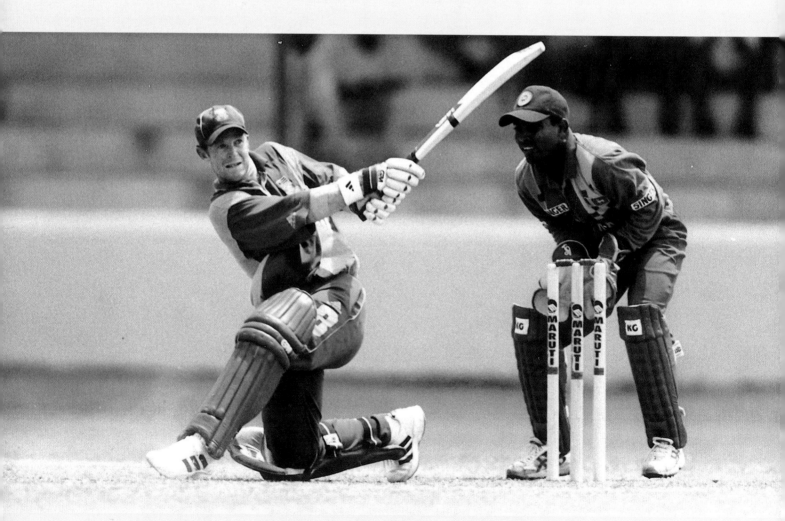

When you gotta go, you gotta go. I normally look for one when I sweep, but if it's there to hit I'll have a go. This is against Sri Lanka in Colombo in 2000 (the wicketkeeper is Kumar Sangakkara) and the likelihood is that I've got frustrated by their spinners and am looking to move a few fielders.

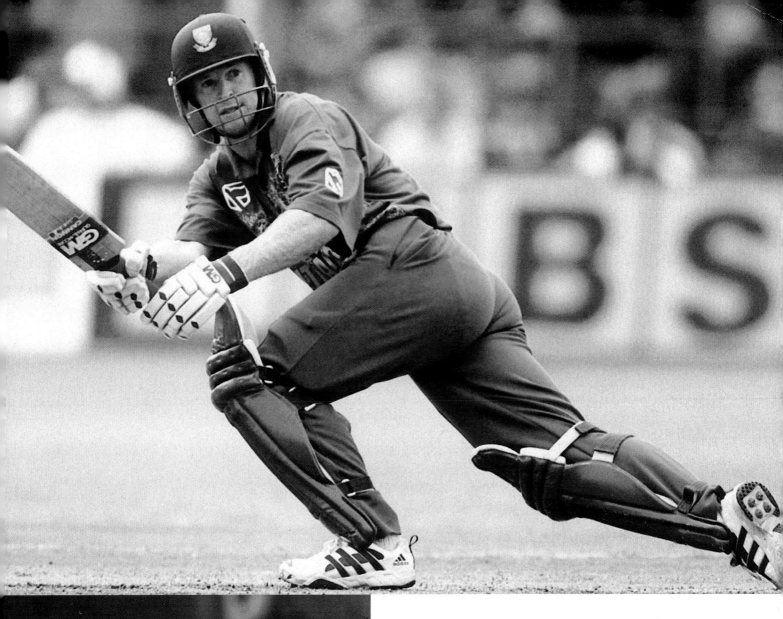

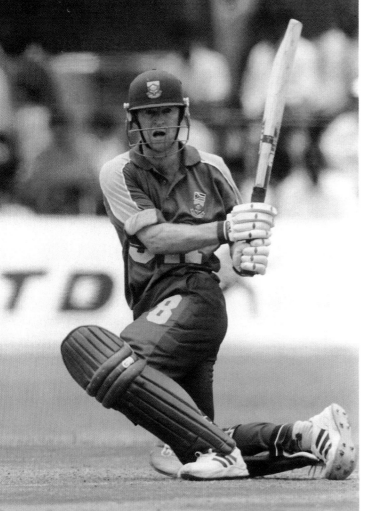

Above: *More of a fetch than a sweep. Against Sri Lanka at St George's Park in April 1998. I'm not in full control, and this might actually be off a medium pacer rather than a spinner.*

The Jolly
Jonty – In Pictures
Sweeper

But Bob helped me a lot with the shot when he explained that if you're using a horizontal bat against the leg-spinner you're hitting into the spin because the ball turns on to the bat. I'm not trying to hit it for four or six so there's not much danger of getting a top edge and actually against the leg-spinner it's more dangerous to play with a straight bat if the ball is turning.

Come one. I'm in a really good position and in control of the ball. I'm not trying to whack it for four, just running it down to fine-leg for a single. No chance of a top edge and even if I'd missed the ball my back leg is covering the stumps. Against Australia in South Africa, 2000.

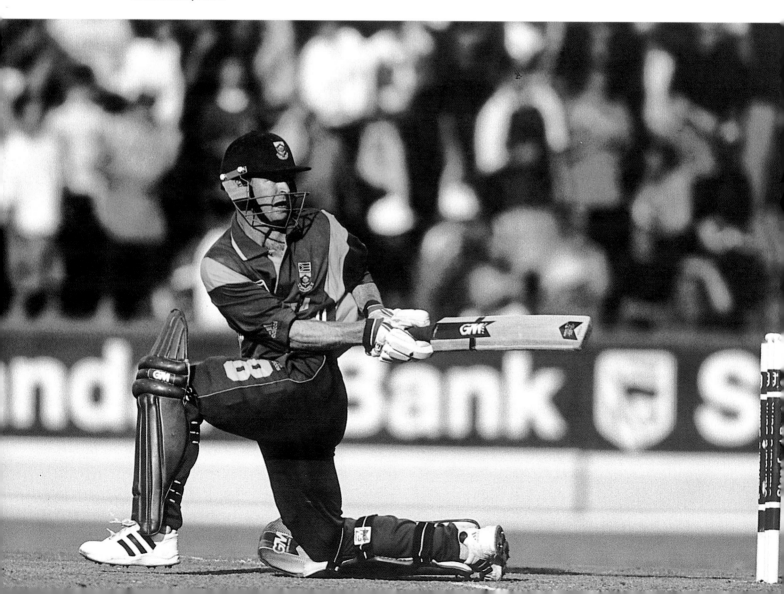

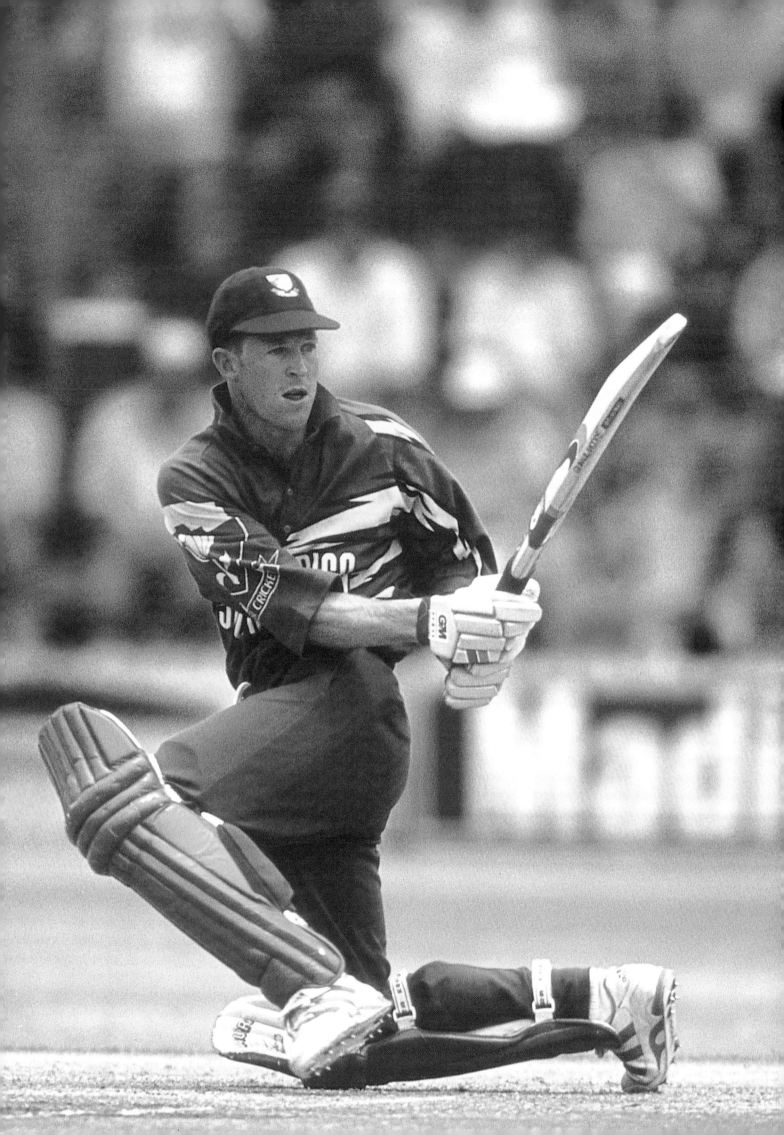

The Jolly
Jonty –In Pictures
Sweeper

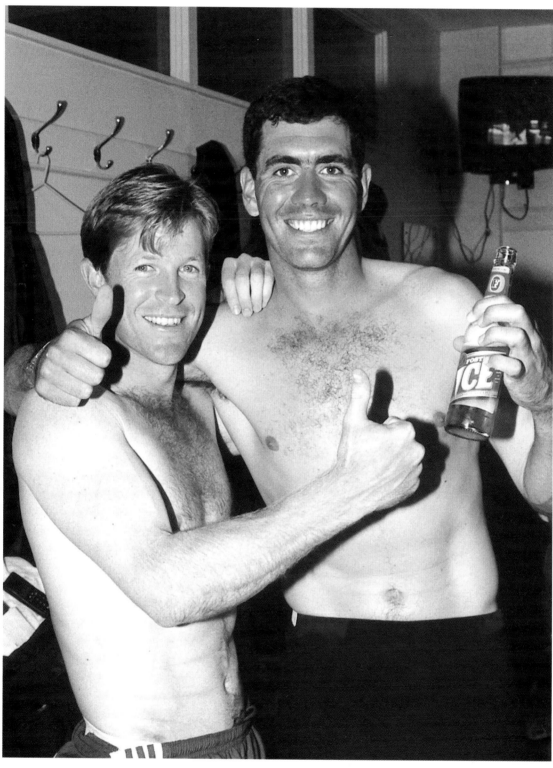

Drinking Ice Beer with Hansie in the changing room in Australia.

Five Forward
Gears And
One Reverse

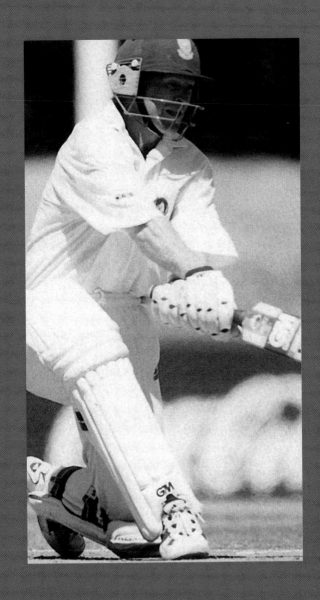

I can't remember the first time I played the reverse sweep. I know that Bob Woolmer had been around in the national set-up for a while and he was encouraging the guys to play the reverse lap, which is where you go down on one knee, hold the bat in the way of the ball and let it run off the face really fine to third-man.

That shot is especially effective against an off-spinner who's got a backward point in place, not so good against a leg-spinner or a slow left armer who might have two men behind square that you've got to beat to score runs.

The reverse sweep is basically used to try and change the field, or the line the bowler's bowling. I'm fairly strong on the leg side and fielding sides tend to pick that up and load it. I'm not so strong that I can clear boundary fielders regularly, so I found that the reverse sweep was a way for me to pick up a boundary.

I remember this picture because it was against Boland in Paarl and Claude Henderson (a slow left armer) was bowling into the rough outside the leg stump with a 7-2 field, just two guys on the off side. This was one that went wrong because I mistimed the shot and instead of hitting it in the middle it struck the toe of the bat and went straight back to the bowler!

But it still worked, because the next two went for four. He tried to bowl a couple of quick arm-balls and I managed to slice both of them through the off side. So even though I missed with the reverse sweep, the effect it had on the bowler earned me runs.

Chalk for my cue, please. This was one of the reverse sweeps that got away. I got my timing wrong and toe ended it straight back to the bowler (fortunately, along the ground). Claude Henderson is the unlucky Boland bowler at Boland Bank Park in Paarl, 1998.

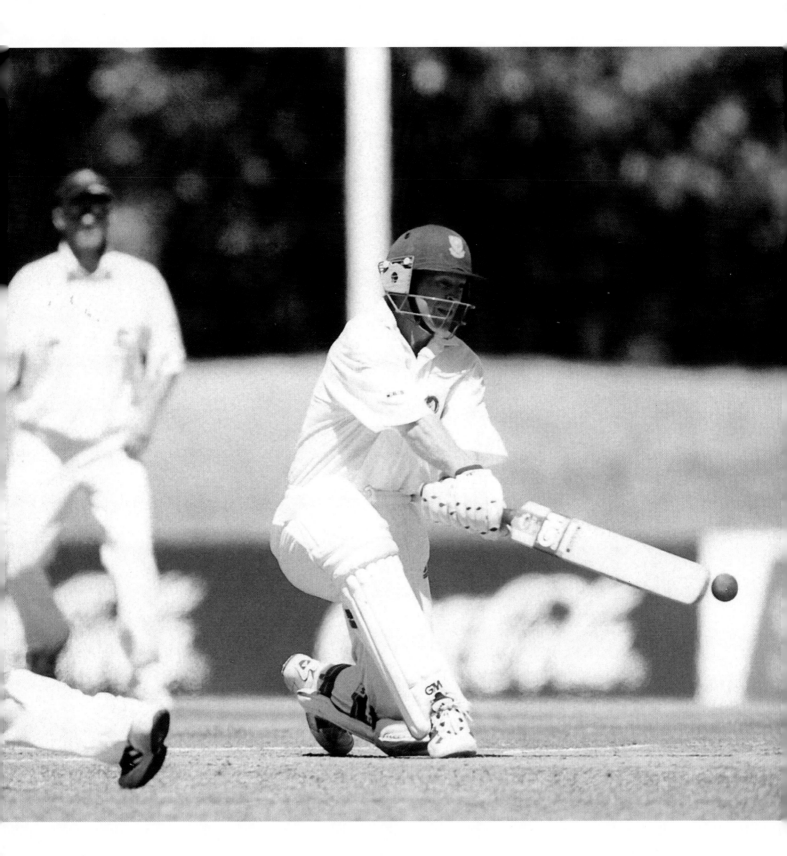

Jonty – In Pictures

This photo was taken in Sri Lanka in a Test match. That might seem odd, but you have to understand the circumstances. The bowler is Murali (Muttiah Muralitharan) who's the best off-spinner in the world. Against Murali it's fatal to just occupy the crease, because sooner or later he's going to bowl you an unplayable ball. So yes, it's a Test match, but you have to do what works and the reverse sweep works for me.

Ironically I got out to Murali playing the reverse sweep in a one-day game. The team was on a roll and we needed one more win to break the record of consecutive one-day victories. We needed 46 to win and I needed 30 of them to get my sixth successive 50. So I got greedy and tried to hit him for four.

The problem is it's a premeditated shot and if the ball is full you get in trouble. It didn't bowl me, but it hit me on the pad and I was given out lbw. Replays showed that the ball was missing leg, but that's one of the risks you take with the shot; if you miss you look so ungainly that the umpires tend to go with the bowler.

Below: **Kandy from a baby. Sri Lankan tour 2000. Sri Lanka are a difficult team to beat in their own backyard because they crowd the bat and just bowl spin all day. One of the few ways to get after Muttiah Muralitharan is to reverse sweep him. This one is off the middle as wicketkeeper Romesh Kaluwitharana will testify. I got sawn off by the umpire later in the innings, allegedly caught bat/pad when the ball came off my foot.**

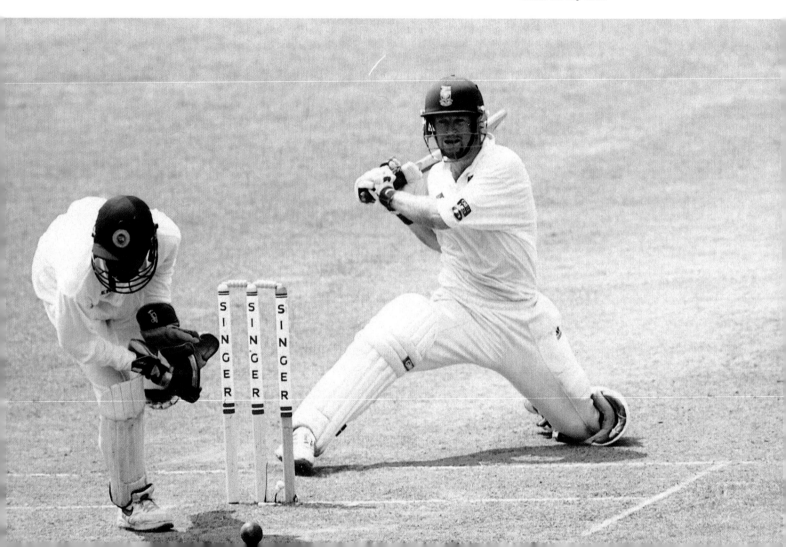

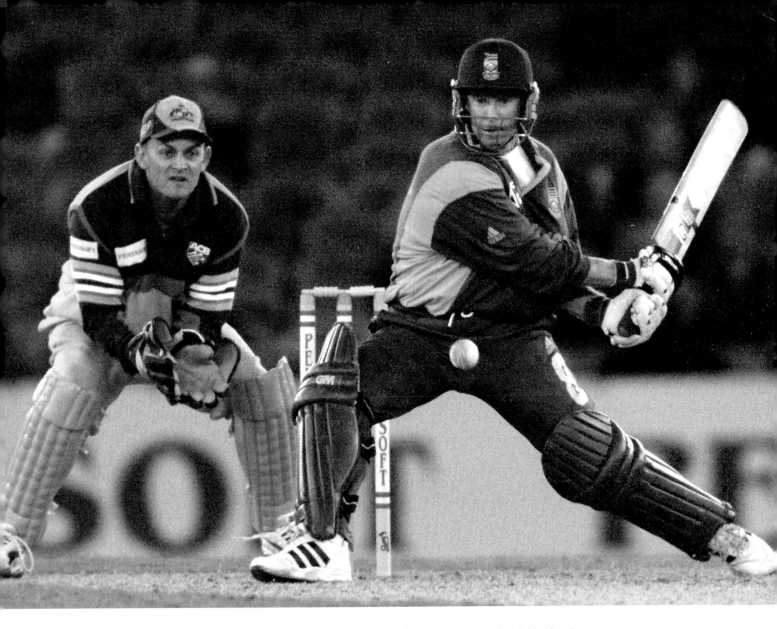

The bowler is Shane Warne at the Colonial Stadium and I'm trying to hit him for six. He generally has two fielders behind square on the off side and on this occasion I remember the ball went for three because I didn't quite middle it.

He got me out next over by bowling a full toss down the leg side when he saw me preparing for the reverse sweep. I had to try and fetch it (left-handed) from outside what was now my off stump and it didn't work. I skied it instead and was caught. But that's one of the problems of doing it against a great bowler. You might succeed once, but the next time he's ready for you.

I've adopted Graham Ford's motto 'Be there, stay there' and I've made up my mind not to play the shot again. But it's not that easy to cut it out and I'd like to see how strong my resolve is!

Above: ***Sweeping Warney to distraction. Colonial Stadium in Melbourne, August 2000. I didn't quite connect with this one so we had to run three. Adam Gilchrist is wondering whether he needs to duck. Unfortunately Shane had his revenge next over when I played the same shot and hit it straight up in the air. Oh well, can't win 'em all.***

Five Forward Gears
And One Reverse

Jonty – In Pictures

Happier times. Off to the nets at Lord's with Hansie, Goolam
Rajah and Fanie. We won that one by 356 runs.

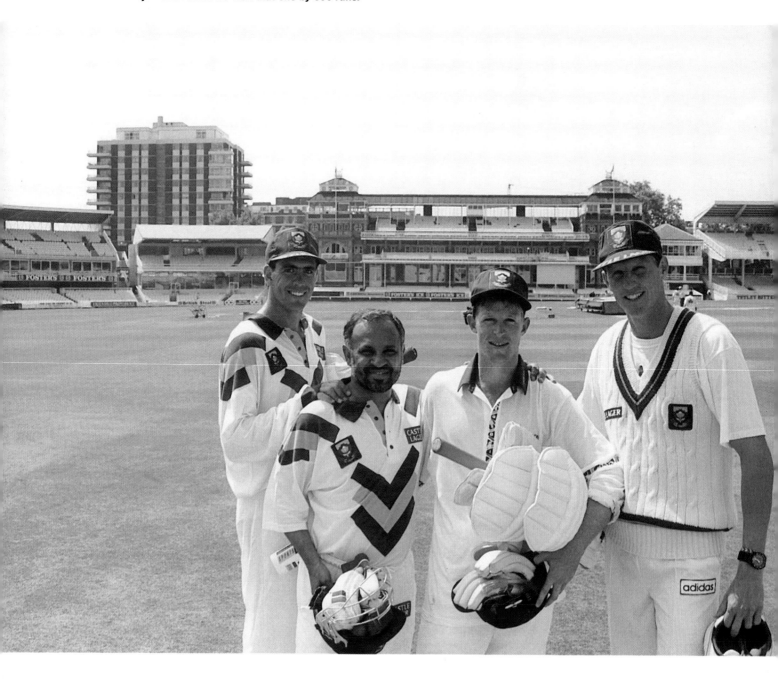

What A
Difference Four
Years Makes

What A Difference Four Years Makes

Jonty – In Pictures

In 1992 Peter Kirsten had played 16 seasons of county cricket in England, but Kepler Wessels was the only one of our squad who had any international experience. Kepler ran a very tight ship. He had a game plan, we stuck to it and it worked.

We didn't know much about any of our opponents, we didn't know what a good score was or how to chase runs, and we certainly didn't know anything about reverse swing. But in a funny way it worked to our advantage, because as much as we were ignorant, no one knew anything about us either.

No one knew how to bowl to Adrian Kuiper, or how to face Richard Snell's boomerangs. And on top of that there were no expectations. No one expected us to get beyond the first round or even to win many games, except maybe against Sri Lanka and New Zealand, which of course were the two games we lost.

How come Daryll Cullinan's got lots of hair and I've got none? I had my hair butchered before the opening ceremony of the 1996 World Cup and when my wife saw the pictures in the South African papers next day she rang up to ask why I wasn't in them, because she didn't recognise me. From left: Goolam Rajah (manager), Gary Kirsten, Jacques Kallis, Daryll Cullinan, Jonty.

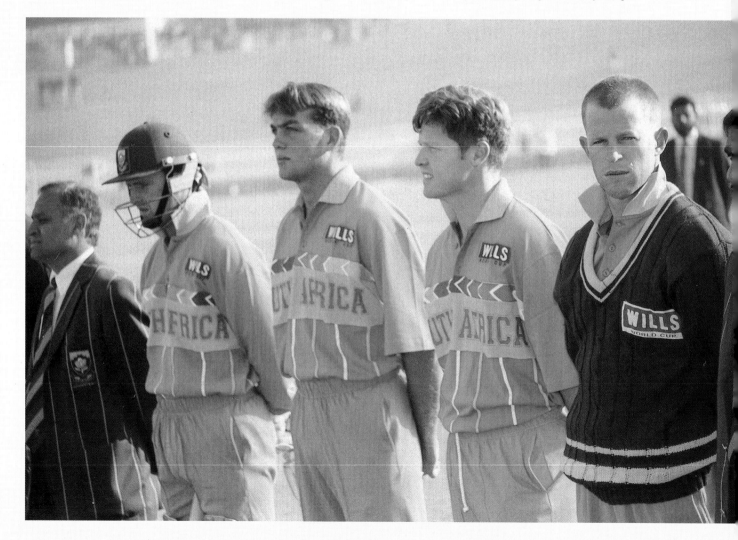

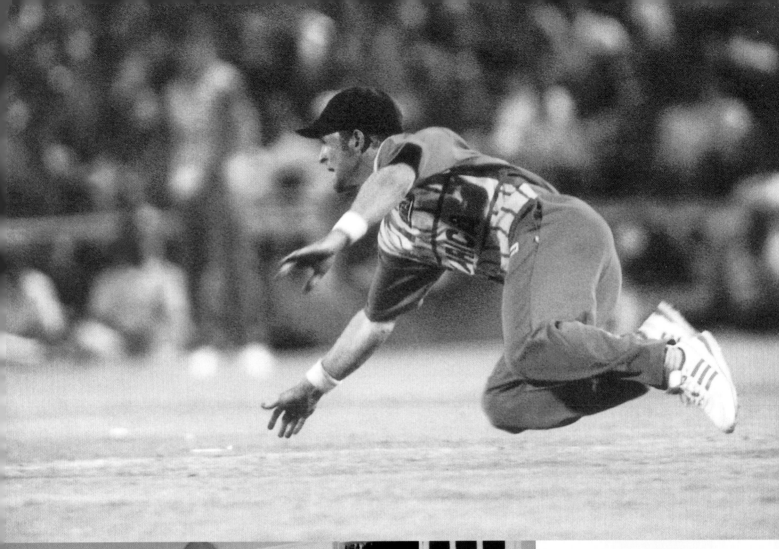

Above: *The blissful moment just before my knees come into contact with rock hard ground.*

Watching a game on TV in Pakistan with a few guests. From left: Shaun Pollock, Craig Smith, Unknown, Brian McMillan, Jonty, Jacques Kallis, Unknown, Allan Donald, Unknown, Goolam Rajah.

What A Difference Four Years Makes

Jonty – In Pictures

We defied expectations in all areas, but in 1996 we were a champion side and it was a big blow not making it further than the quarter-finals. Bob Woolmer had been with us for two years and had turned us round from a side that followed orders to one that backed its own ability. Bob's motto was 'believe in yourself' and while we still had a team goal he didn't mind whether you went left, right or straight to get there.

Guys like Daryll Cullinan and Jacques Kallis might have found it difficult to play under Kepler. He was perfect for the team we had then, but if there were guys who wanted to try different ways they might have ended up bumping heads with Kepler. Bob and Hansie worked well together as a team and they would say 'use the ability that you've got and we'll see you at the end'. Bob's favourite phrase was 'express yourself'.

Right: *Lara celebrates his match-winning hundred. He scored 111 off 94 balls. The West Indies made 264-8 and we fell 19 runs short.*

Below: *Eyes in the back of my head.*

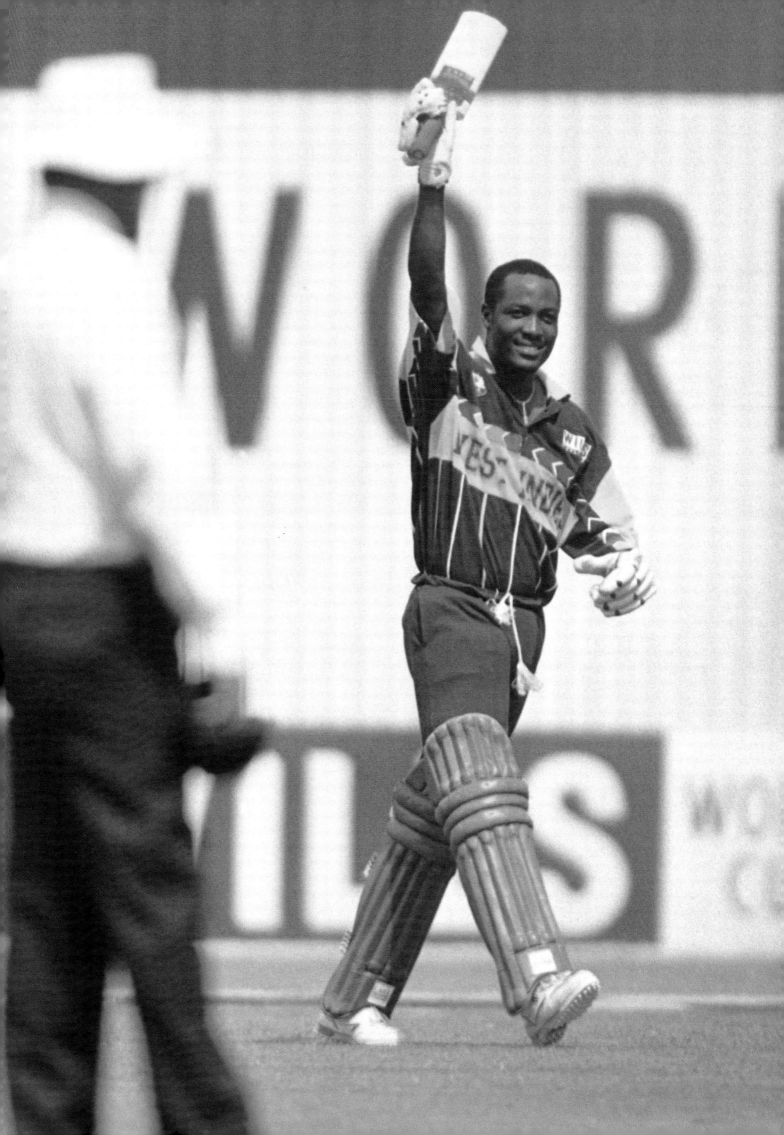

In 1996 we won all five of our league games and then lost the quarter-final against the West Indies. The thing about one-day cricket is that one bloke can make a difference and in this instance an hour and a half of Brian Lara won the game.

We were very tense going into the game. I dropped a catch early on off Sherwin Campbell, and although it wasn't too costly it set the tone for the innings. We dropped Lara early in his innings and I can remember being more tense than I'd ever been in a game.

We weren't complacent, because although the West Indies had lost to Kenya they're the kind of side who can beat anyone on their day. So we weren't thinking that we were going to walk all over them, but at the back of our minds there was the thought that we'd won all our games, but that it's hard to keep churning out great performances and just now you're going to have a bad day.

It was a big blow because whereas in 1992 we were just happy to be there and there were no expectations, in 1996 we were expected to win. But having said that, Sri Lanka deserved their success because they were the team who came with something different. The pinch hitter system that they used changed the face of one-day cricket.

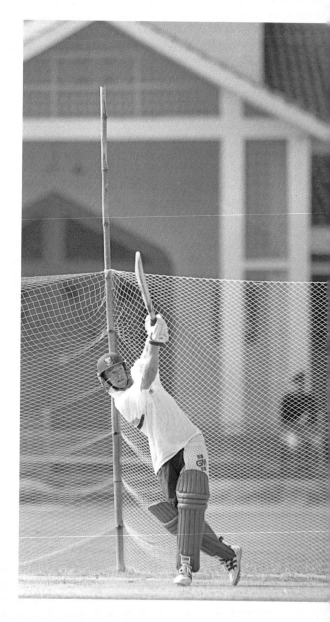

Practising in the nets in Karachi.

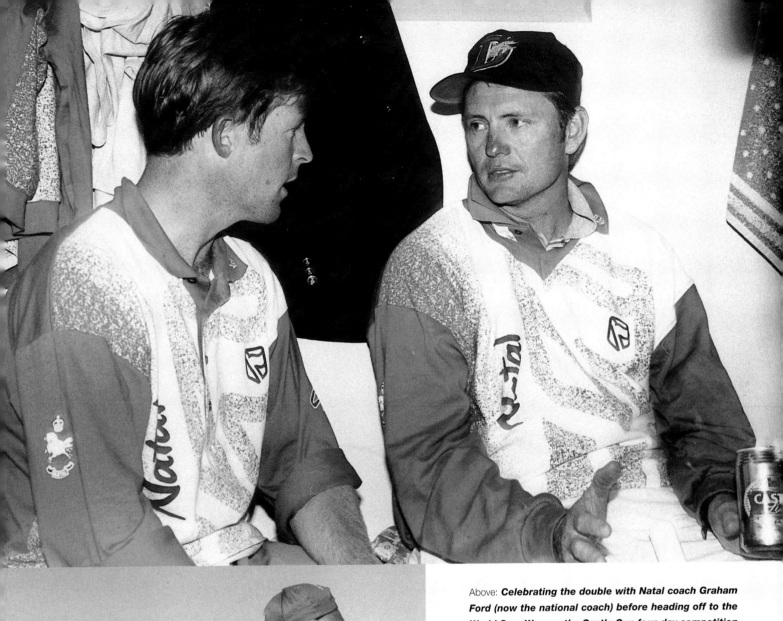

Above: **Celebrating the double with Natal coach Graham Ford (now the national coach) before heading off to the World Cup. We won the Castle Cup four-day competition and the Standard Bank one-day series.**

Left: **I'm hardly likely to refuse an autograph to a man with an AK47!**

Jonty – In Pictures
What A Difference Four Years Makes

Below: *Look mom, I'm famous! This picture of me taken at the 1992 World Cup was used to promote the 1996 version all over the sub-continent.*

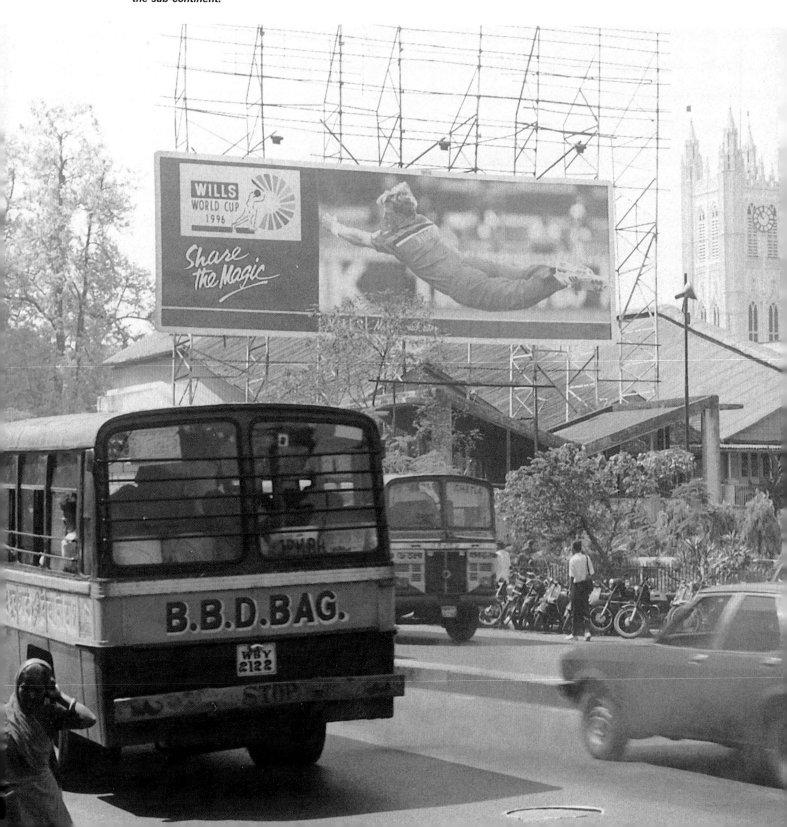

Run, Baby, Run!

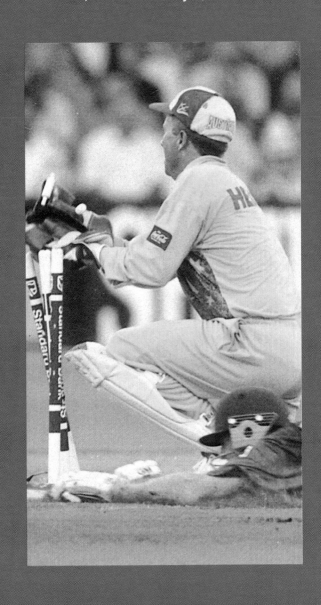

Run, Baby, Run!

You can't put pressure on the fielding team if you don't run the first one hard. I remember cutting a ball down to third-man against the West Indies and I turned for two, not believing that there was any more than a single in it. But Merv Dillon looked up, saw me coming and let the ball slip through his legs for four.

It does put pressure on your partner, but I'm not just running and saying, 'I'm safe, never mind about the other guy'. I'm also aware of who I'm running with, so I'm not going to take two to the cover boundary if I'm batting with Lance Klusener, especially if the fielding team is shouting, 'Throw it at Lance's end.'

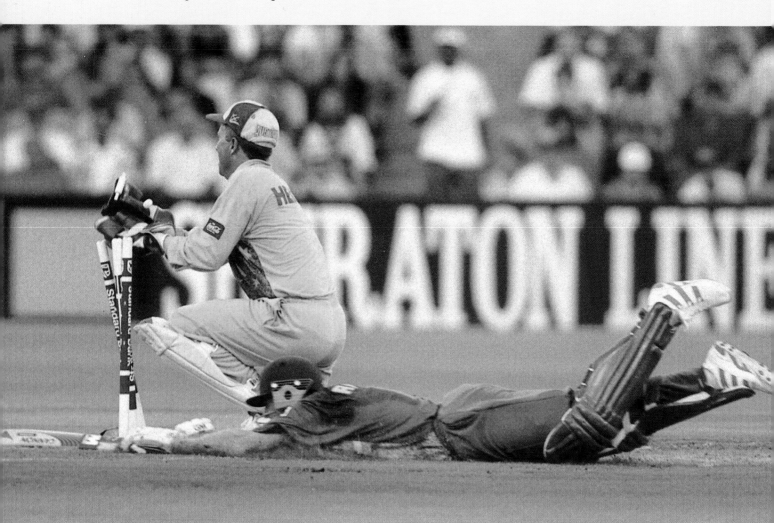

In by a nose. Kingsmead 1998, the Australian wicketkeeper is Ian Healy and I'm not out. People wonder why I dive and it's because the third umpire is on the fielder's side. Generally my singles are pretty well judged and the dive tends to be when I'm coming back for two. I'll see the throw coming in and know I'm in trouble. A dive can save you a frame on the camera and that's the difference between in and out.

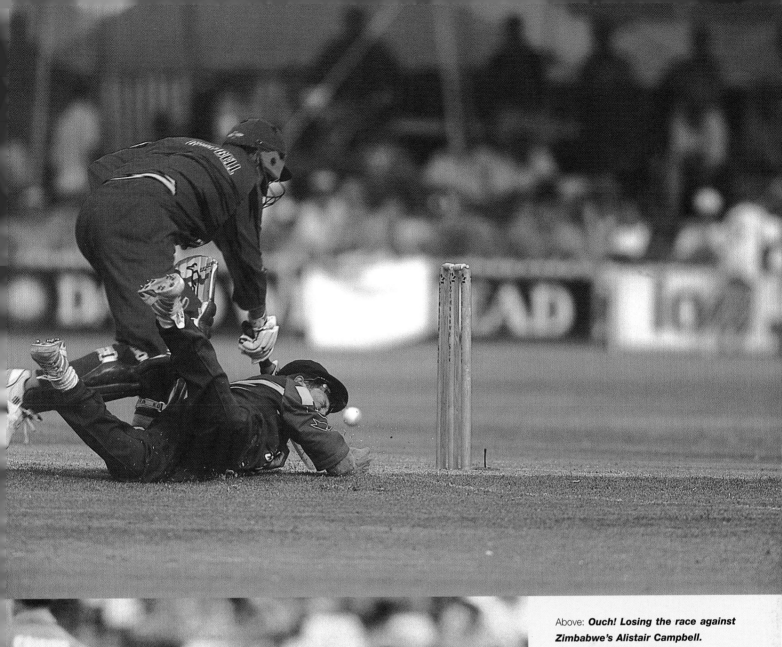

Above: *Ouch! Losing the race against Zimbabwe's Alistair Campbell.*

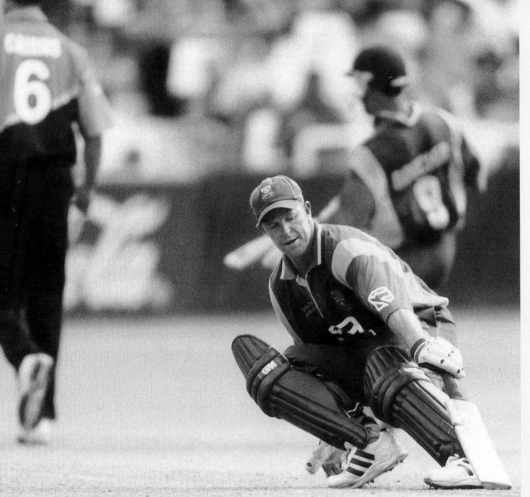

Left: *How low can you go? In a hurry to get back for two against New Zealand in South Africa, 2000. The bowler is Chris Cairns and my batting partner is Mark Boucher. An example of the value of spikes.*

Run, Baby, Run!

Jonty – In Pictures

At the non-striker's end you've got to watch the throw. In the South African side if we're in the field we like third-man and fine-leg to get the ball in as quickly as possible to show the batsmen that there's a good arm down there so watch out.

But if I'm batting and I see someone down there who hasn't got a great arm, I'm going to take him on. Shane Warne fielded down there after his shoulder operation and for someone like Courtney Walsh who has to bowl the ball back in I'm looking for three!

Right: *Yes, no, wait, sorry. I'm already on the run as the ball hits the bat, so heaven help the poor guy at the other end.*

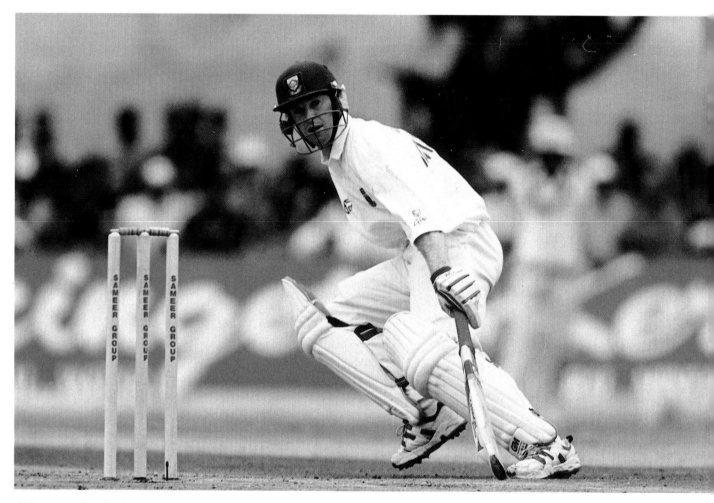

This was against Pakistan in Kenya. It was the first time anyone had seen Shahid Afridi. He scored the fastest ever one-day century, but he was really in the side for his leg-spin bowling. He had a deadly quicker ball and in this match he got a wicket and then gave the quicker one to Pat Symcox who had been sent in as a pinch hitter. That was the end of Symmo, bowled first ball, and Daryll Cullinan got it on the hat-trick ball. Daryll didn't see it, but luckily it fizzed past off stump and we ended up putting on a record partnership. We both got hundreds. This picture was taken towards the end of the innings, because you can see I'm tired and turning a bit warily.

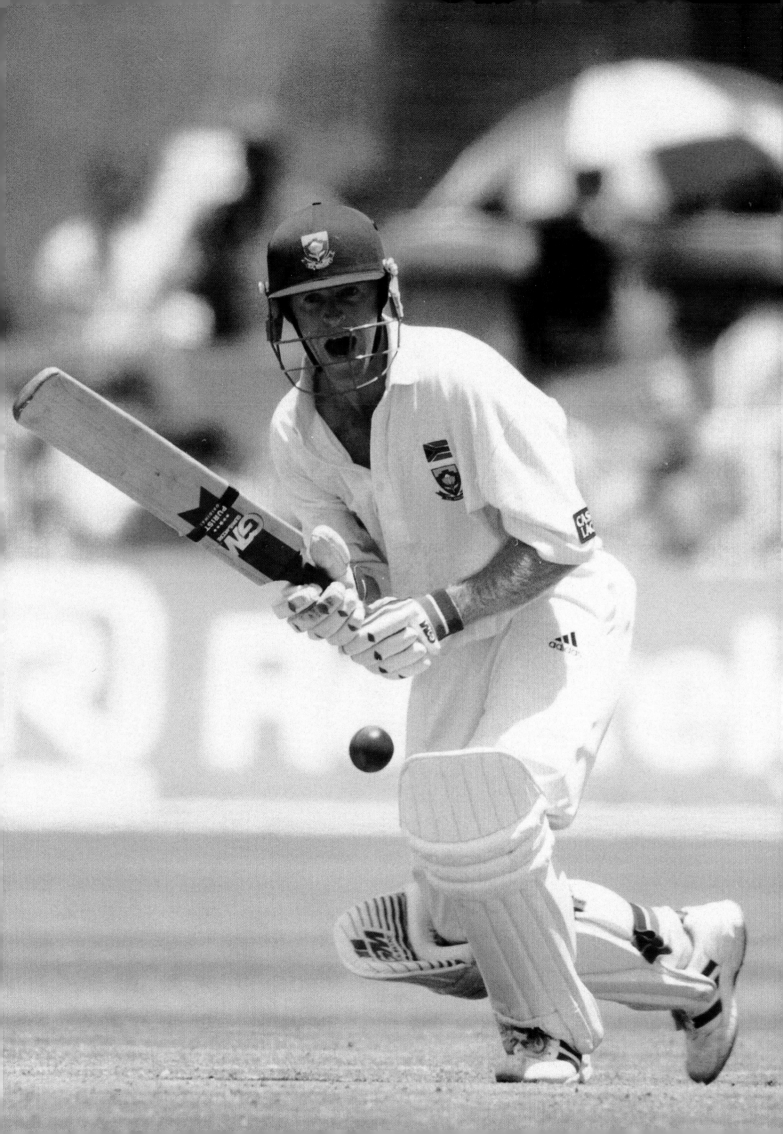

Run, Baby, Run!

Jonty – In Pictures

The best arm from the deep I've ever seen was Fanie de Villiers. He was a record javelin thrower and as soon as the ball went down to him at third-man or fine-leg we would shout in Afrikaans, 'Skiet hom uit, Fanie' (shoot him out), because it was like a rocket coming back. A lot of the Test teams hadn't seen Fanie and every game they would take him on thinking that he's a bowler and he's off balance, and in would come this rocket.

Below: *Safe! Newlands 1998. The ball is still on its way and I may be diving to get underneath it. Jacques Kallis looks a little concerned at the non-striker's end, but he'll have some more sprinting to do yet.*

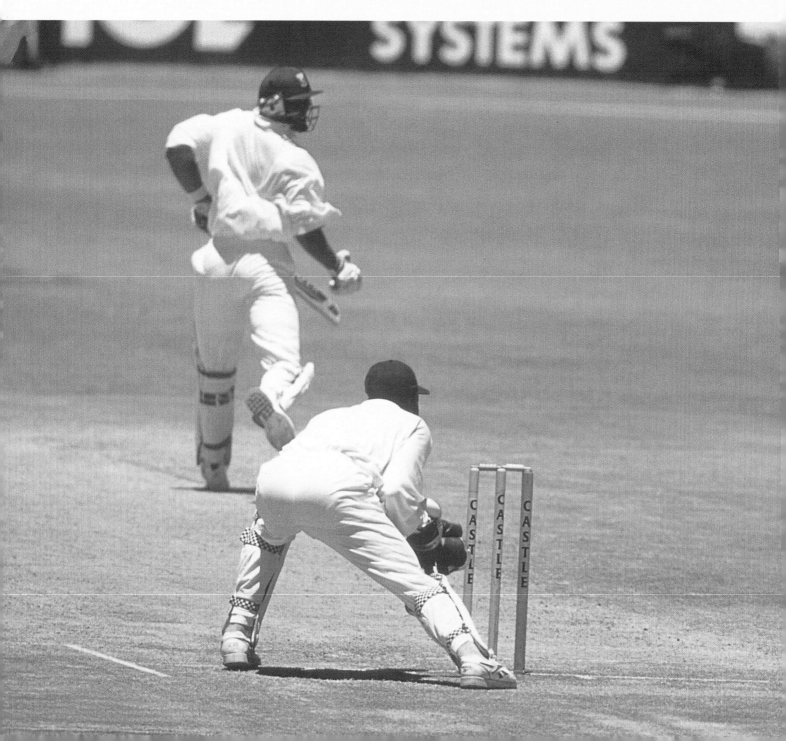

Top right: *They love me in India.*

Bottom right: *Sensible attire for the nets in Calcutta where it's very hot and very dry.*

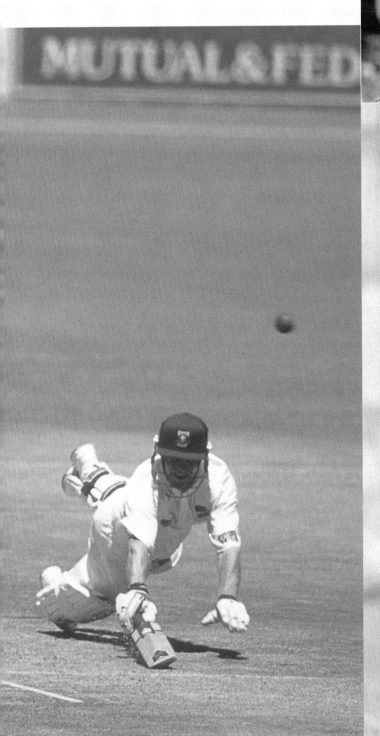

Run, Baby, Run!

Jonty – In Pictures

Why did I do that? Contemplating my dismissal against the West Indies in Bloemfontein in 1999.
Nantie Hayward is sitting below me.

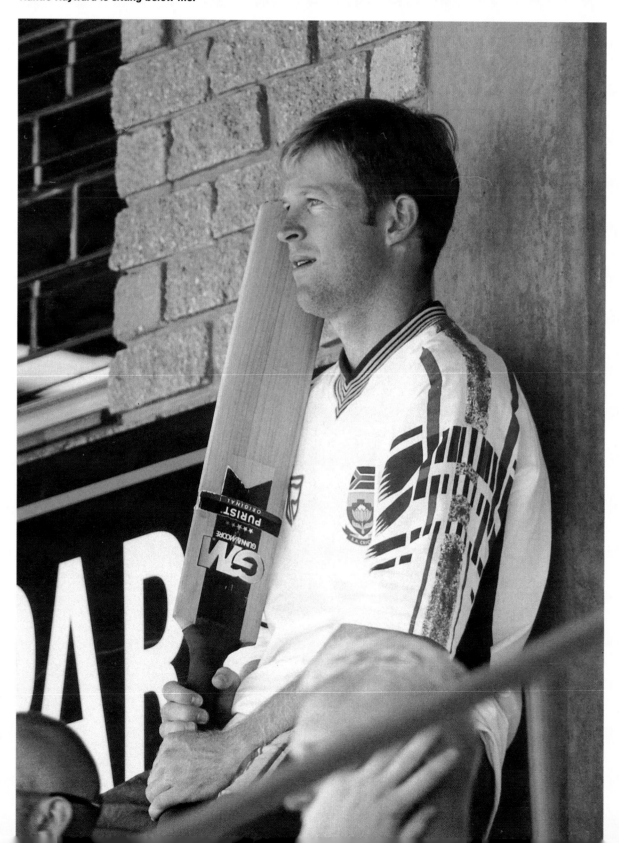

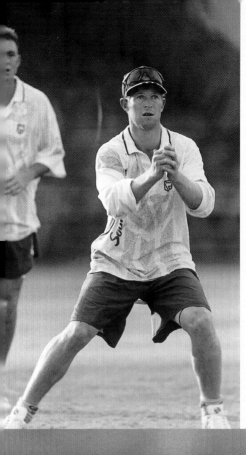

Left: **Practising in South Africa in 1995. A rare picture of Herschelle Gibbs in the days when he had hair!**

Below: **Batting in spikes at the 1996 World Cup. I don't like batting with rubber-soled boots because I find I need a lot of traction to be able to turn quickly. I once saw Mike Atherton get run out on 99 at Lord's when he slipped and I vowed it would never happen to me.**

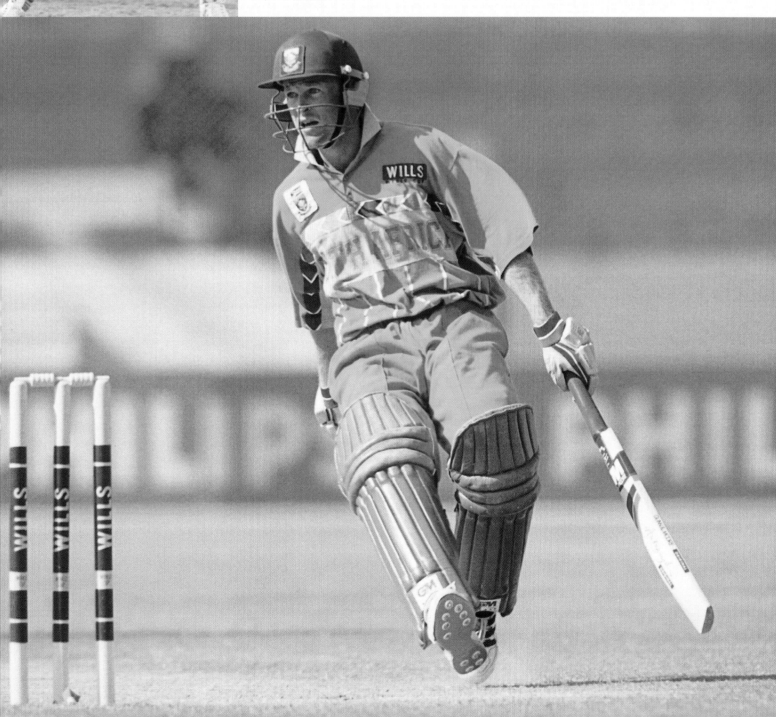

A Century
At Lord's

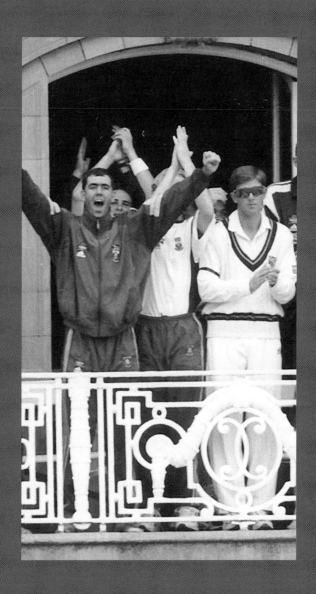

England in 1998 was my comeback to Test cricket. The first Test at Edgbaston was rain affected and we were in trouble against the moving ball. Lance Klusener and I batted us out of trouble and I got out for 95. I remember thinking what a pity it was that I didn't get the hundred, but I guess it was fitting that I was able to do it at the home of cricket.

It was the usual English cloudy day at Lord's and we got to bat first. We were in trouble at 60 odd for four when I joined Hansie and we put on a good stand of 184. It was one of those days when things go for you.

When I was on about 10 I drove hard at the ball and was dropped in the slips by Mike Atherton high above his head. Later in the innings he caught me, but this time it was off a Dominic Cork no ball. Then when I was on 93 Dean Headley hit me on the front pad and it went through to the back pad. The umpire heard two noises and assumed that I'd got a little inside edge, but I hadn't and I was straight in front.

The next ball Headley hit me on the head with a bouncer. I tried to pull it and it hit me straight on the helmet, but actually it was the best thing that could have happened to me in the circumstances. Craig Smith came on to the pitch to treat me and that took up about five minutes and it really helped me deal with the nervous 90s, because the next six or seven runs came in a calmer mood.

It was one of those days where if you hang around you're going to get a good ball and Hansie and I took the attack to them. They had three slips and a gully most of the time and consequently there were lots of gaps in the field. When the moment came Mark Ealham was bowling back of a length outside off-stump and I hoicked him over mid-wicket.

It didn't come off the middle of the bat so Shaun Pollock and I had to run three. I remember going up to Shaun and telling him that a hundred at Lord's was overrated, which was my way of trying to keep calm! The point being that I had got to my milestone, but the team was still, if not in trouble, then certainly not controlling the game. As it turned out I didn't get many more, but I hung around a while. Then our bowlers bowled brilliantly and we won the Test in just over three days.

In the crowd were the Maritzburg College first team on tour and my old coach Mike Bechet was with them. He wasn't just my coach, he taught me a lot of life skills, particularly about determination. He was such a disciplined coach that he and Kepler would have gone together particularly well.

They both ran the same kind of ship and Mike prepared me for Kepler. Kepler was a shock for a lot of people, but not for me because my whole senior school period had been with Mike Bechet, a disciplinarian of note. So it was fitting that Mike was there when I got my hundred. I went down on to the field after the close to sign autographs and it was great to see him and the schoolboys at a moment like that.

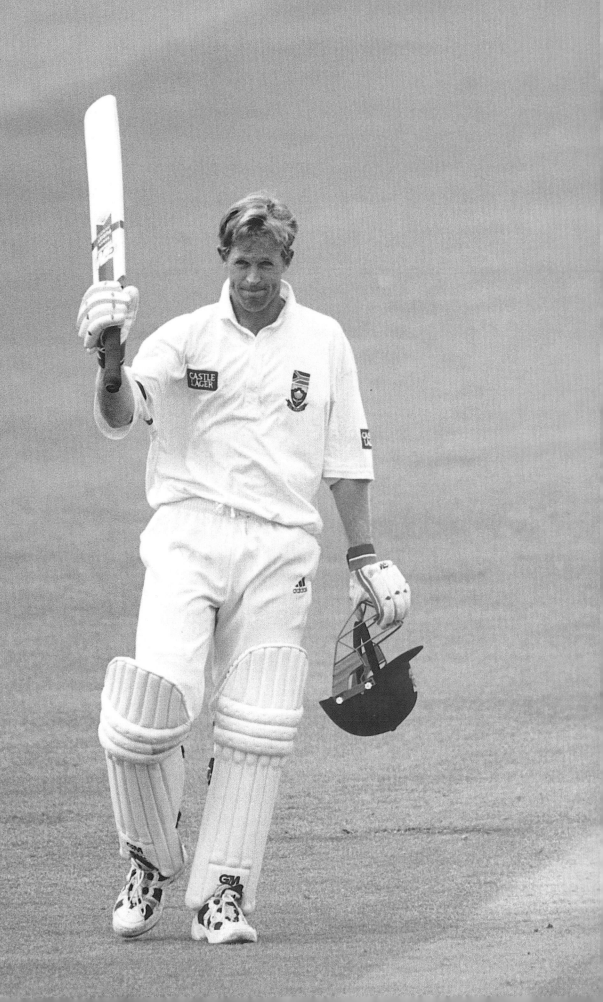

A Century
Jonty – In Pictures
At Lord's

Below: *A special moment as the team applauds my hundred on the balcony at Lord's. From left: Bob Woolmer (coach), Corrie van Zyl (bowling coach), Hansie Cronje, Gerhardus Liebenberg, Craig Smith, Adam Bacher, Gary Kirsten, Daryll Cullinan, Allan Donald.*

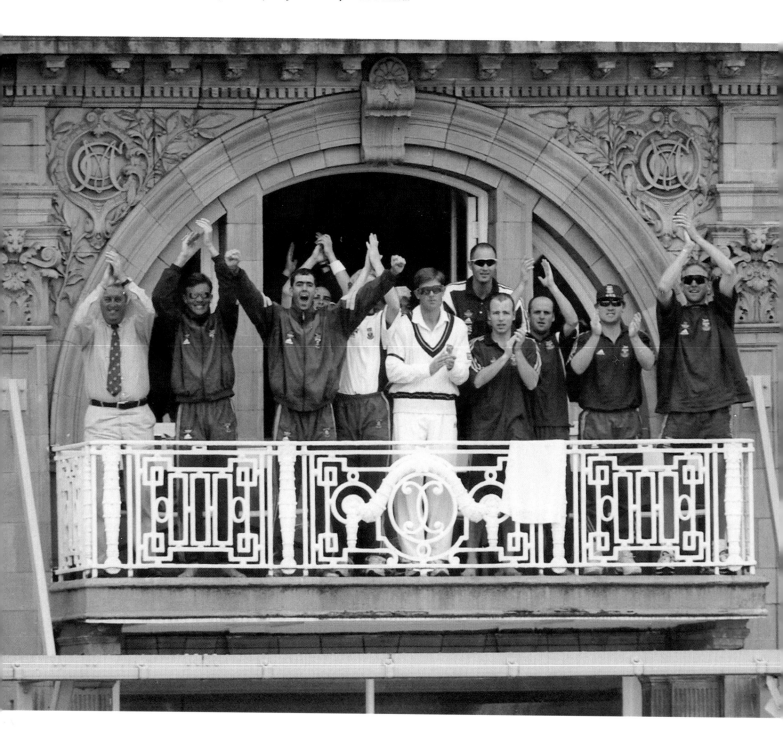

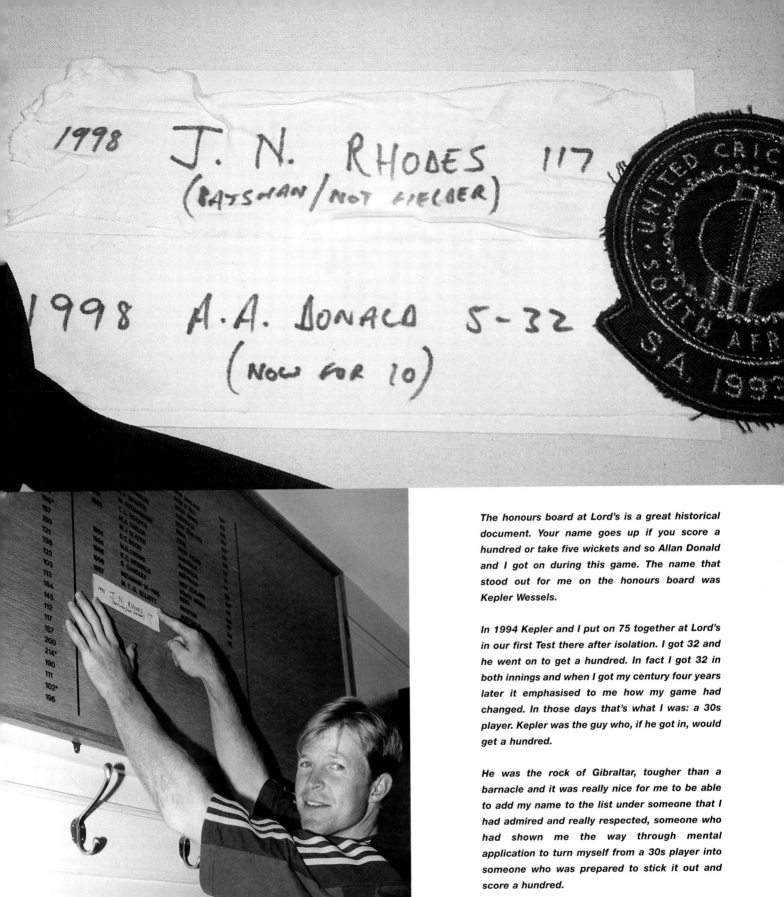

1998 J. N. RHODES 117
(BATSMAN/NOT FIELDER)

1998 A.A. DONALD 5-32
(NOW FOR 10)

The honours board at Lord's is a great historical document. Your name goes up if you score a hundred or take five wickets and so Allan Donald and I got on during this game. The name that stood out for me on the honours board was Kepler Wessels.

In 1994 Kepler and I put on 75 together at Lord's in our first Test there after isolation. I got 32 and he went on to get a hundred. In fact I got 32 in both innings and when I got my century four years later it emphasised to me how my game had changed. In those days that's what I was: a 30s player. Kepler was the guy who, if he got in, would get a hundred.

He was the rock of Gibraltar, tougher than a barnacle and it was really nice for me to be able to add my name to the list under someone that I had admired and really respected, someone who had shown me the way through mental application to turn myself from a 30s player into someone who was prepared to stick it out and score a hundred.

A Century
Jonty –In Pictures
At Lord's

At Lord's the team wore black armbands because Jackie McGlew had just passed away. There had always been comparisons made between Jackie and me because we both went to Maritzburg College, both captained Natal at a very young age and he was chairman of selectors for SA Schools in 1987 when both Hansie and I played. The first time I met Jackie was when I was captain of Natal Schools and he called me in after a game and said that my team was guilty of excessive appealing! From left: Jonty, Shaun Pollock and Darryl Hair.

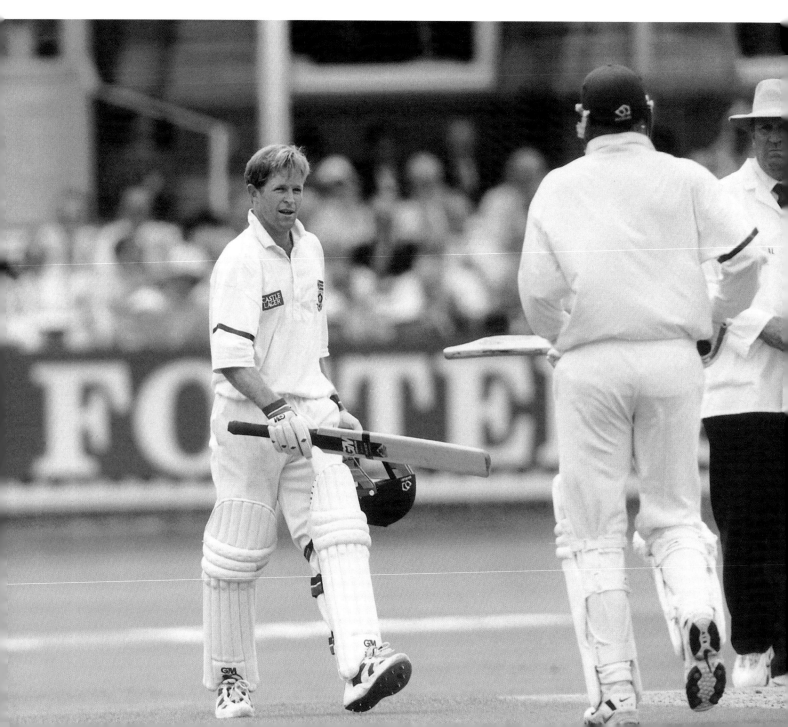

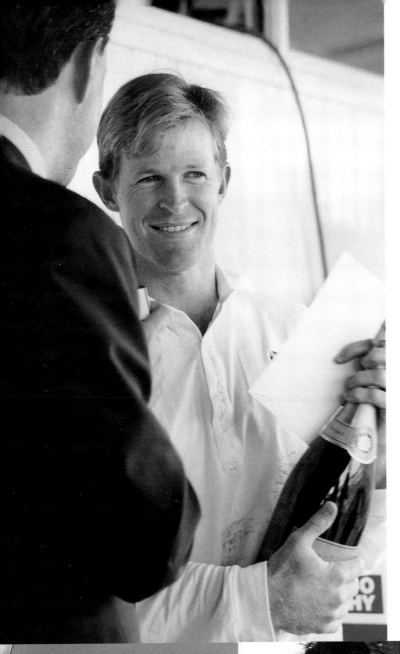

Overleaf: *Former WP wicket keeper Richie Ryall now makes his living from pictures of significant sporting moments.*

Left: *My one and only Man of the Match award in Test cricket.*

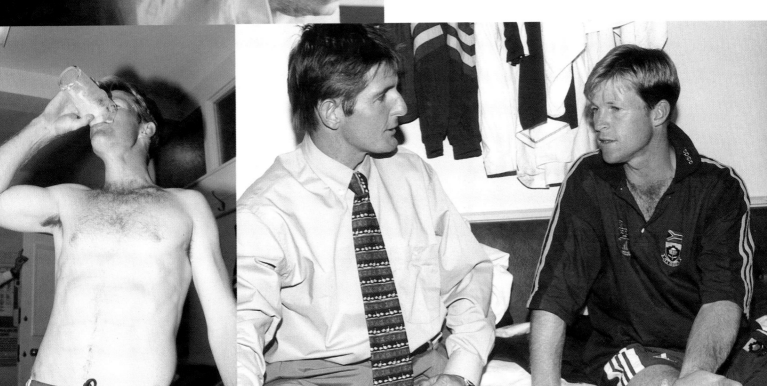

A down-down of Castle in the dressing room after the match.

South African tennis player Christo van Rensburg was in town and came into the dressing room to celebrate with us.

ENGLAND

Alec Stewart (c) w/c

Mike Atherton

Steve James

Nasser Hussain

Graham Thorpe

Mark Ramprakash

Mark Ealham

Dominic Cork

Robert Croft

Dean Headley

Angus Fraser

B. Hutton — J. Marshall

David Lloyd (coach)

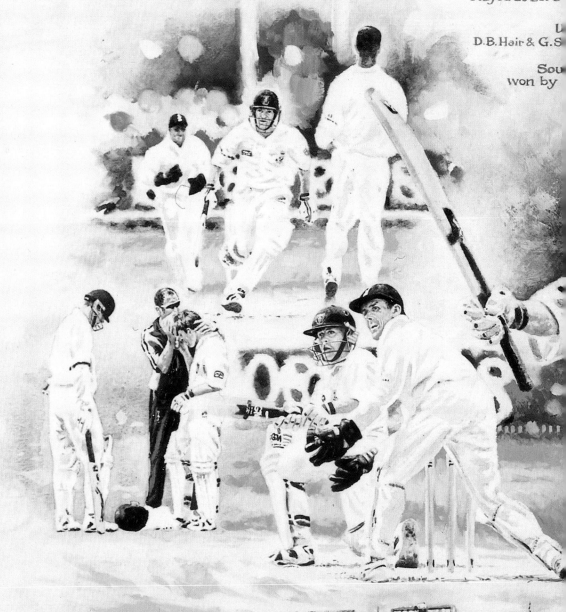

SOUTH AFRICA

Mar
of the M

Jonty Rh

A.M. Bacher c Stewart b Cork	22		
G. Kirsten b Cork	4	- not out	9
J.H. Kallis b Cork	0		
D.J. Cullinan c Stewart b Cork	16	- not out	5
W.J. Cronje* c Ramprakash b Ealham	81		
J.N. Rhodes c Stewart b Fraser	117	(299 mins, 200 balls, 14×4)	
S.M. Pollock c Hussain b Cork	14		
M.V. Boucher c Stewart b Headley	35		
L. Klusener b Headley	34		
A.A. Donald not out	7		
P.R. Adams c Stewart b Cork	3		
Extras (b1, lb 20, nb 6)	27	(nb 1)	1
Total (108.1 overs)	360	(1.1 overs)	15

EN

	O	M
Fraser	31	8
Cork	31.1	5
Headley	22	5
Ealham	15	2
Croft	9	3

SOU

Donald	15.3	5
Pollock	18	5
Klusener	8	5
Kallis	5	3
Adams		
Cronje		

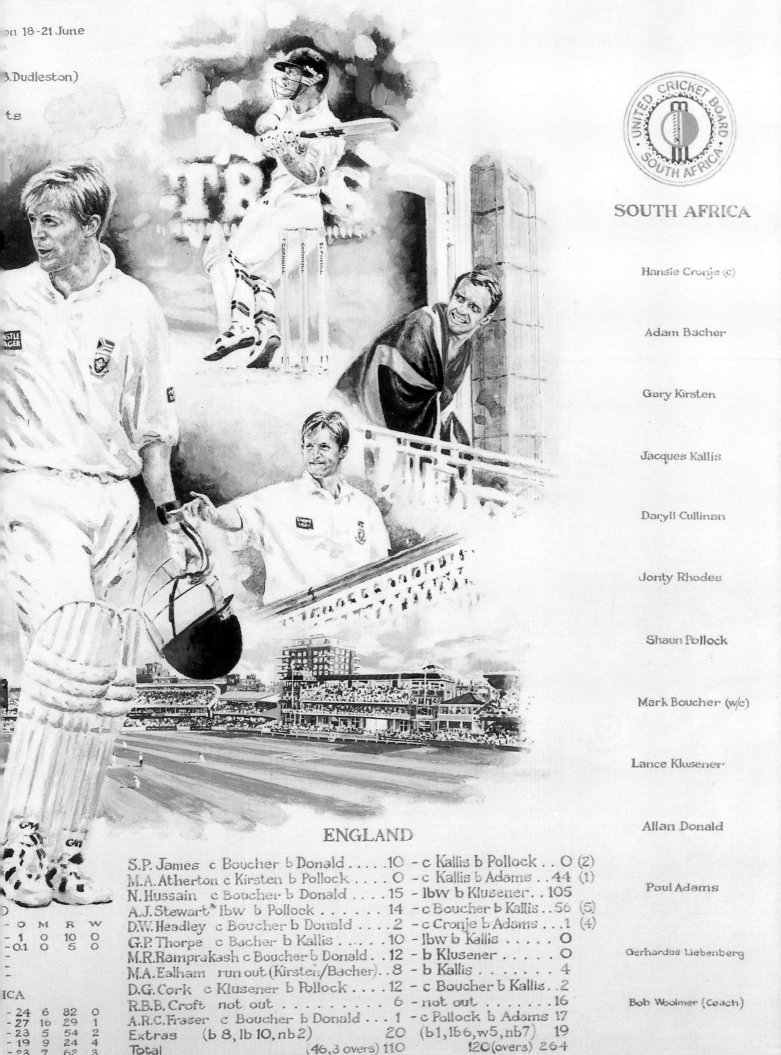

ENGLAND

on 18-21 June

B.Dudleston)

SOUTH AFRICA

Hansie Cronje (c)

Adam Bacher

Gary Kirsten

Jacques Kallis

Daryll Cullinan

Jonty Rhodes

Shaun Pollock

Mark Boucher (w/c)

Lance Klusener

Allan Donald

Paul Adams

Gerhardus Liebenberg

Bob Woolmer (Coach)

	O	M	R	W
	-1	0	10	0
	-0.1	0	5	0

ICA

	-24	6	82	0
	-27	16	29	1
	-23	5	54	2
	-19	9	24	4
	-23	7	62	3
	-4	2	6	0

ENGLAND

S.P. James c Boucher b Donald 10	- c Kallis b Pollock .. O (2)	
M.A. Atherton c Kirsten b Pollock O	- c Kallis b Adams .. 44 (1)	
N. Hussain c Boucher b Donald 15	- lbw b Klusener .. 105	
A.J. Stewart* lbw b Pollock 14	- c Boucher b Kallis .. 56 (5)	
D.W. Headley c Boucher b Donald 2	- c Cronje b Adams .. 1 (4)	
G.P. Thorpe c Bacher b Kallis 10	- lbw b Kallis O	
M.R. Ramprakash c Boucher b Donald .. 12	- b Klusener O	
M.A. Ealham run out (Kirsten/Bacher).. 8	- b Kallis 4	
D.G. Cork c Klusener b Pollock 12	- c Boucher b Kallis .. 2	
R.B.B. Croft not out 6	- not out 16	
A.R.C. Fraser c Boucher b Donald ... 1	- c Pollock b Adams 17	
Extras (b 8, lb 10, nb 2) 20	(b1, lb6, w5, nb7) 19	
Total (46,3 overs) 110	120 (overs) 264	

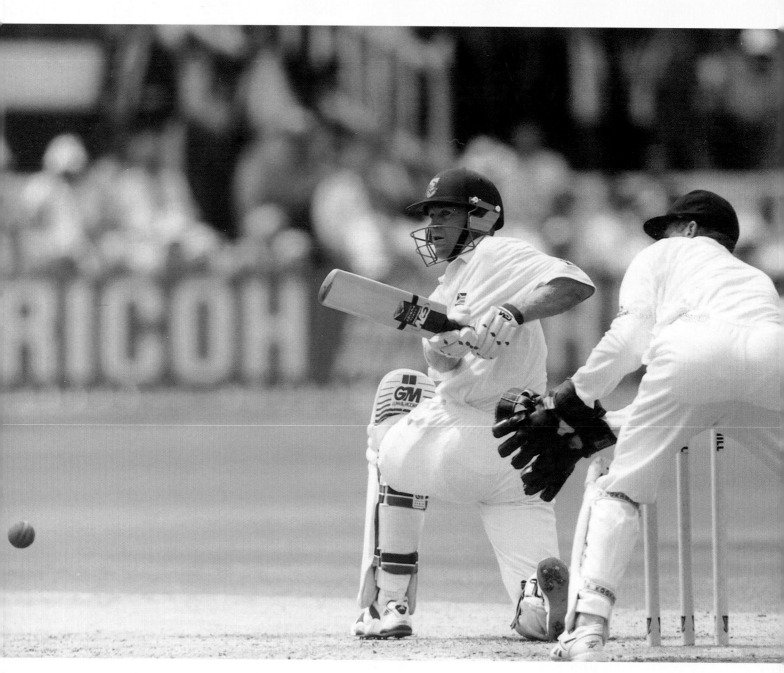

Getting on top of a sweep at Lord's on the way to my century.
Alec Stewart is the wicketkeeper.

Defying Gravity

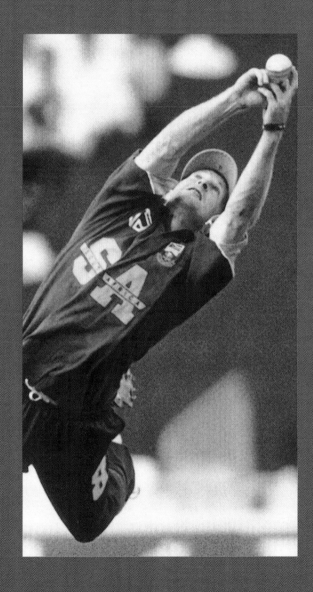

It was in England in 1998, at Edgbaston in Birmingham. We were in a triangular series that also included Sri Lanka and we'd lost our first two games. So we needed to beat England by a certain number of runs to qualify for the final. I think we needed to bowl them out for 198, but we didn't manage to and although we won the game we didn't make it to the final.

The bowler is Mike Rindel. He bowls left arm seamers normally, but here he's bowling left arm spin. The batsman is Robert Croft, I'm at extra cover and he thought he'd cleared me comfortably, but I jumped up and caught it in my fingertips.

You have days when you drop sitters, but other days you catch everything and this was one of those days. It lodged in my fingertips and I only had two fingers on it at the end. I remember the look on his face because he thought he'd hit it for four.

The key is that you can see I'm watching the ball all the way into my hands. I've dropped a few above my head. Brian Lara was one, but he hits the ball so hard that it can happen and I remember on that occasion that I didn't see the ball all the way, like I did with Croft.

I'm jumping up to the ball, so that although I haven't really got hold of it I'm not going to lose it when I hit the deck because I'm on my feet. The danger when you're diving horizontally, is when your elbows hit the ground the impact can knock the ball out.

Ironically, although it's a great picture it wouldn't be in my personal top 10 of catches taken. Generally speaking the good ones are those that you don't see, the ones that you've caught by instinct. In this instance the difficulty is that I've had time to think about how I'm going to make the catch and that can sometimes work against you.

This picture got used in a lot of endorsements because it's simply a great action shot. I'm not sure what photographers do to get these kinds of pictures.

The answer to that question is this: All Sport had three photographers at the game and a fourth, Adrian Murrell, turned up just to try and get a picture of Jonty. He sat for half an hour, got the picture and left, knowing that through a bit of good luck and a bit of good management he'd not get a better one if he sat there for the rest of the day.

Right: **Come fly with me. Catching Robert Croft at Edgbaston in 1998. You can see the Emirates Air advertising hoarding in the background. They used this picture to advertise their airline.**

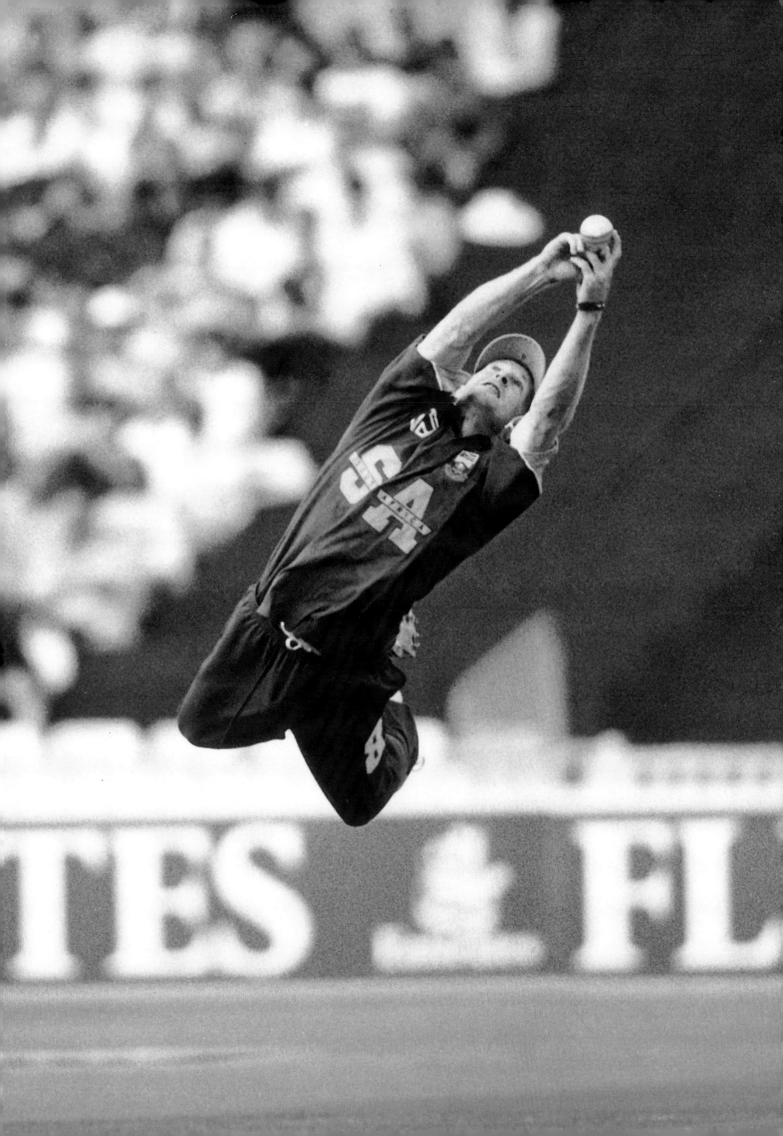

Defying
Jonty – In Pictures
Gravity

A photographer taking his life in his hands. Lord's 1998.

Catches Win
Matches

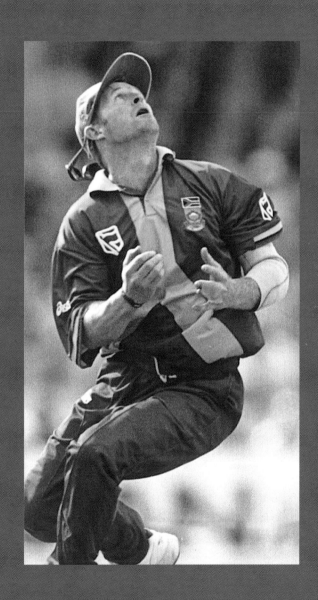

Catches Win Matches

Jonty – In Pictures

This sequence was taken at the Oval in the World Cup of 1999. We're playing England and believe it or not, the guy I caught was Robert Croft again! I remember it very clearly because he just walked off shaking his head. He was interviewed after the game and he said he didn't know what he had to do to get the ball past me.

It was towards the end of the innings when you get a lot of miss-hits and, again, it wasn't the pace of the shot that made it difficult, it was the fact that it was at an uncomfortable height. But this is where practice pays off because we do a lot of work with soft balls that bounce out if you don't catch them properly.

I played in a charity match in Pakistan and Shahid Afridi came up to me and asked me, 'How do you do it?' because he rates himself as one of the better fielders in their team. I said it's because I practise in a very specific way. I get more 'roasties' (grass burns) and sore hands in practice than I do in the game.

Graham Ford takes a tennis racket and what we call 'slaz balls' and fires them at us. Corrie van Zyl also does a lot of work with us and you find that because the ball isn't hard it bounces out and you have to learn to recover it. So what I do isn't unique, the whole team is trained to do exactly that.

With this catch people asked whether I had planned to palm it up and I actually did. I could only get one hand to it and as I jumped I planned to knock it in the air, turn and finish the catch on the rebound. I took one that was even better against Zimbabwe in Durban. The batsman was Andy Flower and I was much closer to the batsman on that occasion. He hit it really hard, but got the same result as Croft.

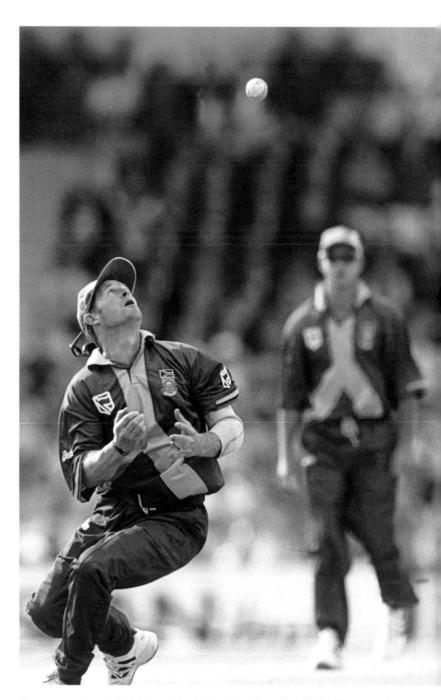

Up, over and out. Catching Robert Croft in the 1999 World Cup match against England at the Oval. Herschelle Gibbs looks as though he knows I'll make the catch and Daryll Cullinan is the first to congratulate me. Actually the catch itself wasn't that hard, but I had to leap to an uncomfortable height to parry the ball up in the first place.

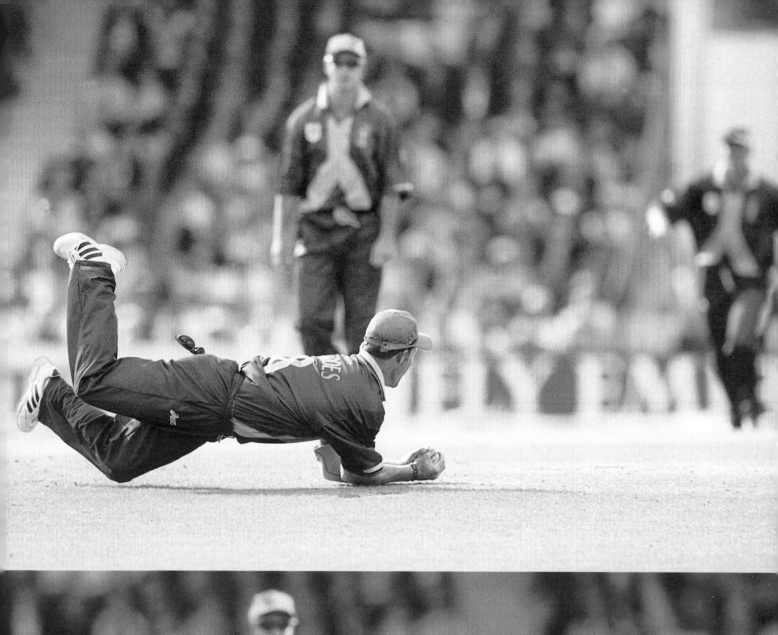
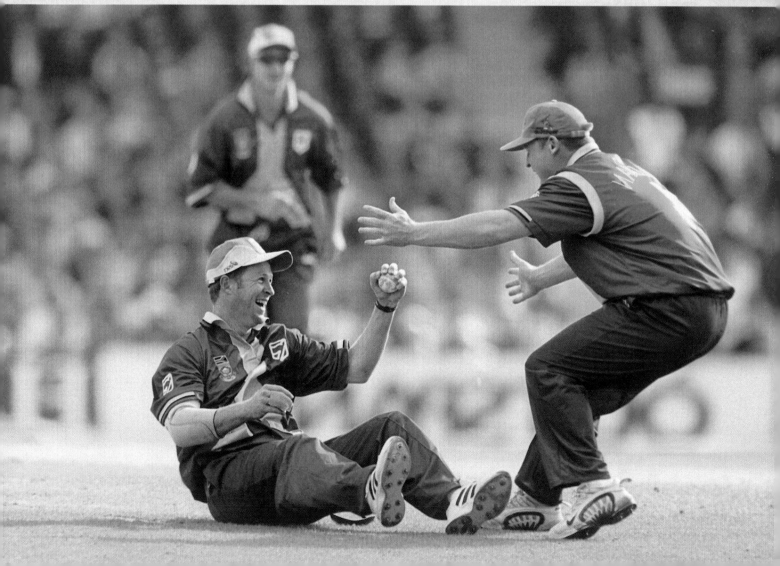

Catches Win
Jonty — In Pictures
Matches

I'm not the kind of guy who can stand around for 90 overs in the day and just occupy space, I like to be involved and when the spin-bowlers are on I can come in and field close. This is a catch that was turned down in Galle, the second Test of the series against Sri Lanka.

It's Chaminda Vaas and the bowler is Paul Adams. I was the only one who appealed and replays showed that it was out. I'm wearing hockey shin pads, which are very lightweight and strong and I'm actually surprised that I'm not wearing a helmet as well, because it's a bit of a myth that you can get badly hurt only at short leg.

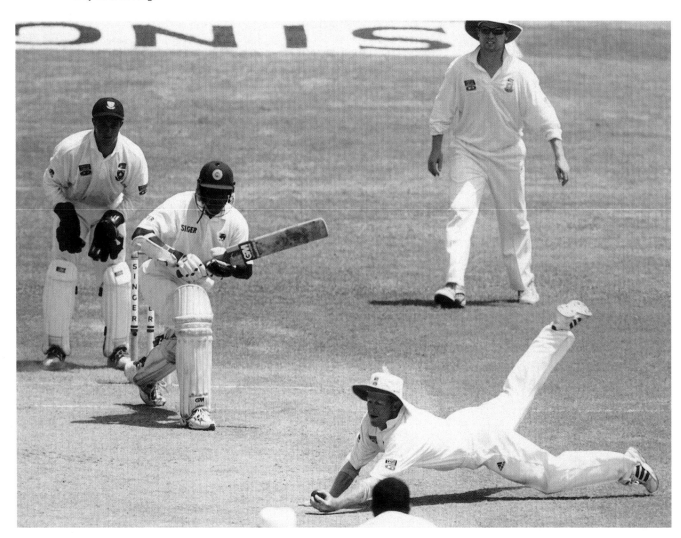

The voice of Jonty crying in the wilderness. Catching Chaminda Vaas off the bowling of Paul Adams in the Test against Sri Lanka in Galle, 2000. Mark Boucher and Daryll Cullinan don't seem too excited, but in fact replays showed that it was out. Unfortunately I was the only one who appealed and umpires rarely give decisions in such circumstances.

Practice makes perfect. Sharjah, April 1996. We made up for losing in the quarter-finals of the World Cup by winning this tournament against Pakistan and India.

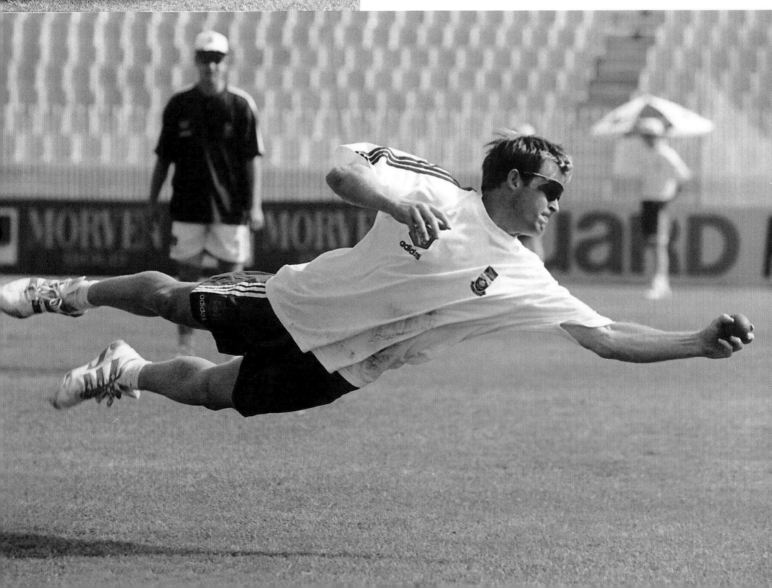

Catches Win
Matches

Jonty – In Pictures

I remember seeing Nick Knight (England) get hurt at silly point playing in a Test match against the West Indies. Kenny Benjamin hit one out of the screws and felled him. So I find that if I wear a helmet I can keep my eyes on the ball all the time. If someone drives the ball I'm not scared of being hit. Often you'll see chances missed because the batsman has hit the ball into his pad and the fielder has turned away to avoid it. With a helmet on you can improve your chances.

Below: *Practising with the 'slaz' ball, Headingley, Yorkshire, 1998. These are the situations where I pick up most of my bumps and bruises. The ball is smaller and softer than a cricket ball and if you don't catch it properly it jumps out. Ideal for practising the kind of catch that Robert Croft is fed up with seeing.*

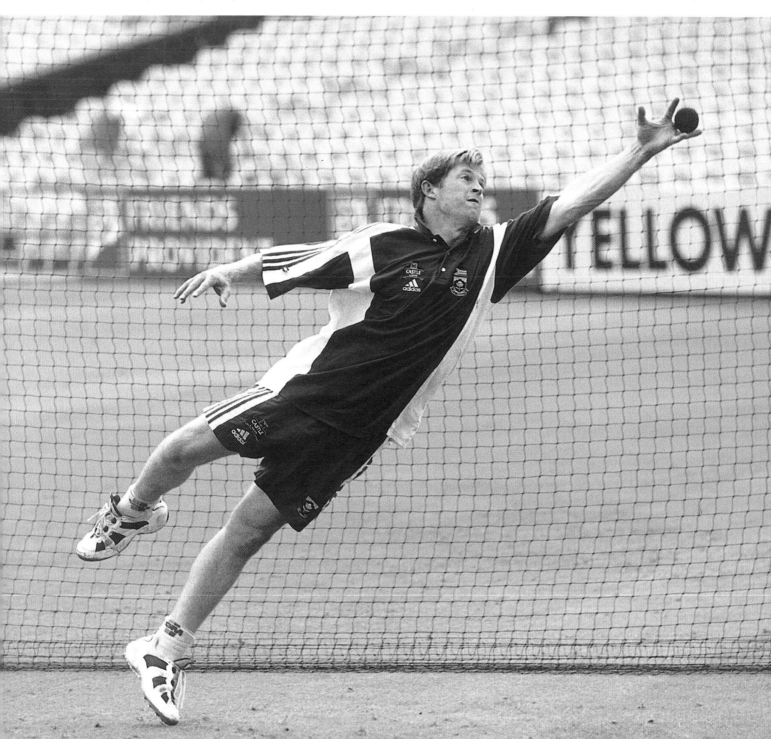

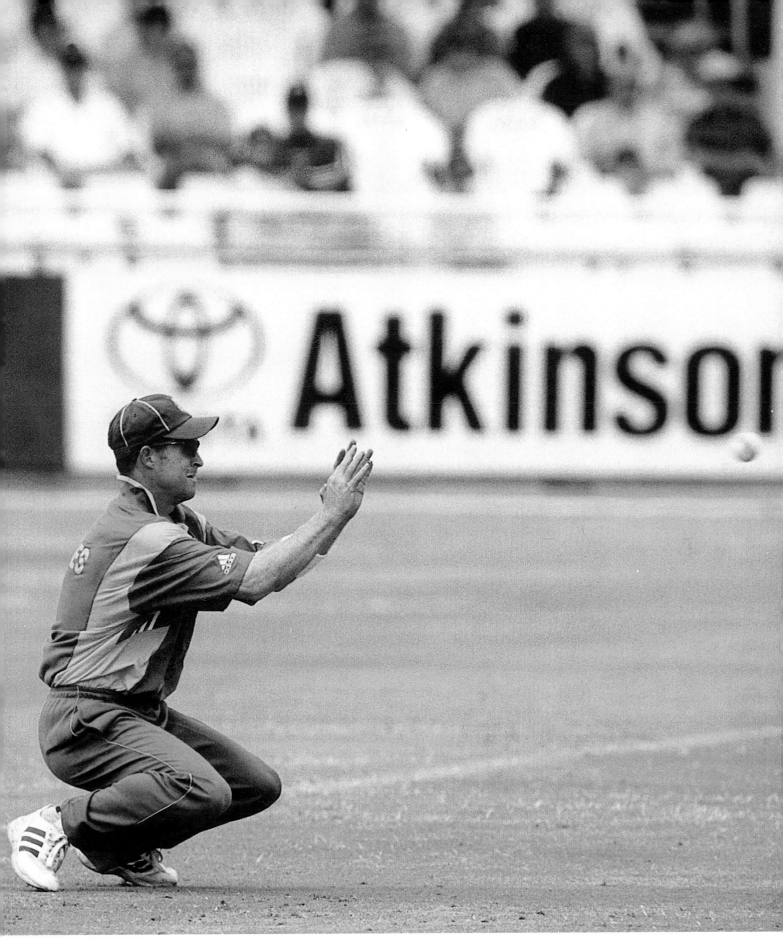

About to take a catch on the edge of the circle, against Australia at Newlands in 2000. I've got myself into a really good position, well balanced, head level with the ball, palms out and ready to take the impact. If I drop this one there's no excuse!

Jonty –In Pictures

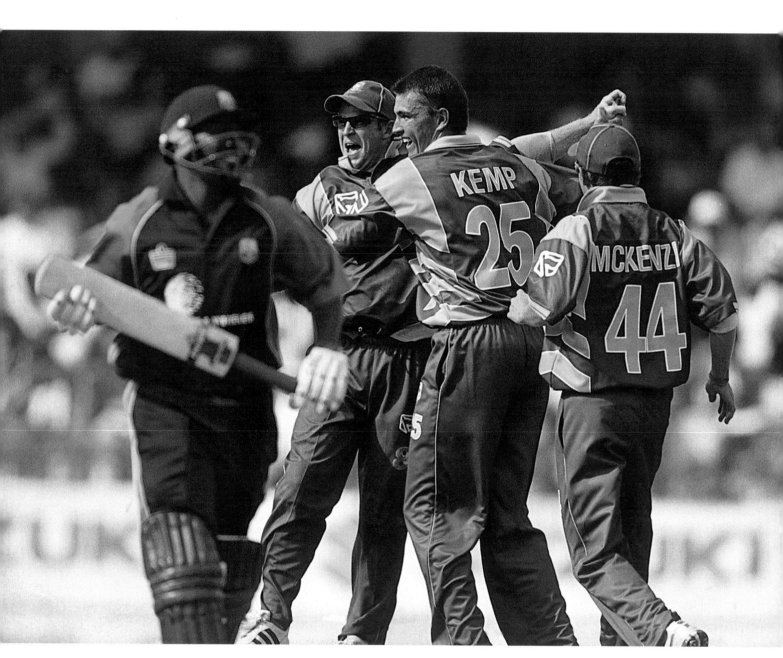

*Celebrating with the younger generation. I've taken a catch off
Justin Kemp's bowling against the West Indies in Antigua, 2001.
Neil McKenzie joins in the celebrations.*

Paying The Price

Paying
Jonty – In Pictures
The Price

If you go into anything in a half-hearted way, that's when you can get injured. It's the same with batting where people ask about the fear factor involved in facing fast bowling. The point is that if you go in to bat with the attitude that you could get hit, or if you're thinking too much about what you're doing, then you're bound to get hit.

In the field I have fractured my hand twice, once courtesy of Steve Waugh who smacked a ball at me very hard, but I've been fortunate that I've never done serious damage against an advertising board. I've hit them hard, but I think my build has helped me. I'm not too tall and ungainly, I'm reasonably stocky and I've learned to fall well, especially on the hockey field. So I can handle myself against the boards, but I'm not tentative. I think if you go in half-heartedly you'll do damage to yourself.

Right: *Thank goodness for helmets. I've got myself into a bad position to play the short ball and I'm lucky that it's missed me because I've taken my eyes off it.*

Below: *Another 'roastie' on the way. Diving to stop the ball in Pakistan. The patch on my shirtsleeve is to cover up the Castle logo. Pakistan is a Muslim state and the advertising of alcohol is banned, much to the chagrin of our team sponsor.*

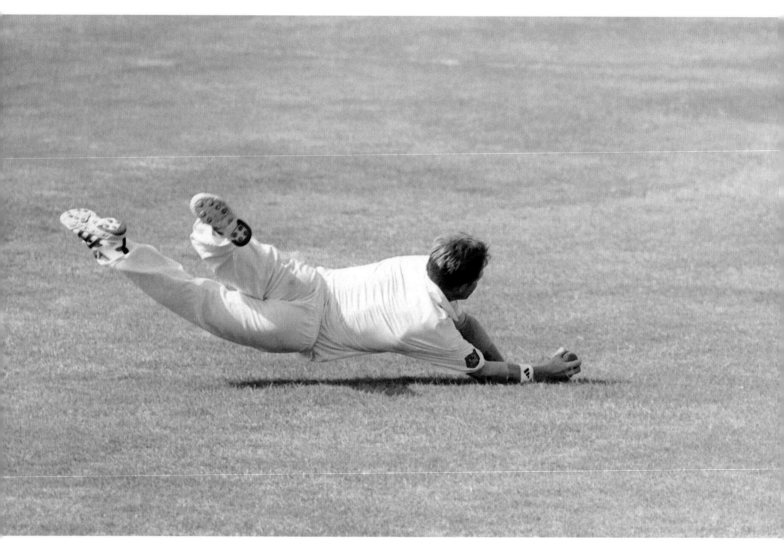

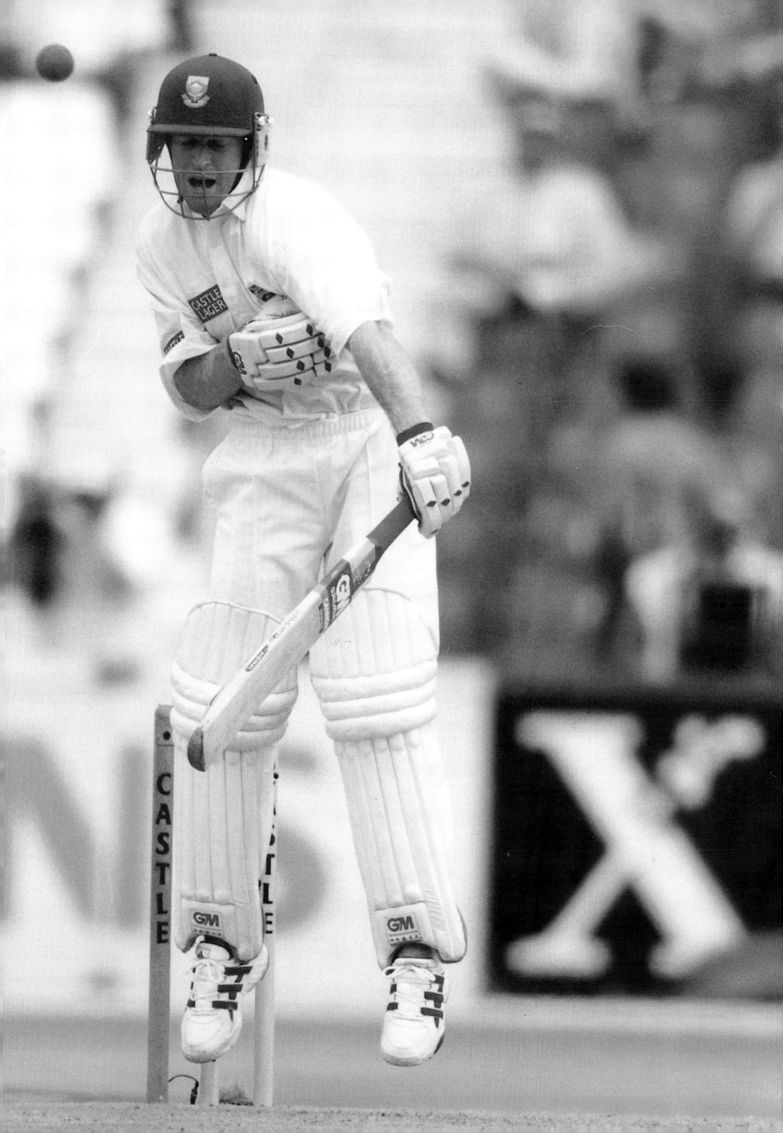

Paying
The Price

Jonty – In Pictures

Playing a big game has an effect on my body. It's like being in a car crash. I suffer from whiplash and as a result my chiropractor and I are best mates. During the cricket season I go to chiro' at least once a month just to have everything clicked back into place. My spine gets out of alignment, my neck gets really stiff and my whole back gets messed up and, of course, that causes problems with the hamstrings.

People wonder why I've retired from Test cricket and the reason is that with all the diving I do I'm down to my last layer of skin! The next generation have got it a little easier. Craig Smith sprays a second skin on to the knees and elbows to stop them from getting damaged. That stops the one thing that I used to hate, which is waking up in the morning and finding that you're stuck to the sheet. It's a horrible feeling, because you know that you're going to have to pull it off and it's going to hurt like hell. But it's something I've learned to live with. I can remember

Below: **Rhodes, retired hurt, for 8. Craig Smith and the ground doctor taking me off to hospital at the Oval in 1994. Devon Malcolm pinned me with a bouncer, which gave me two days in hospital and a sore head. I was able to bat in the second innings, but Malcolm blew us away with a ferocious display of fast bowling. He took 9-57 and we lost by eight wickets.**

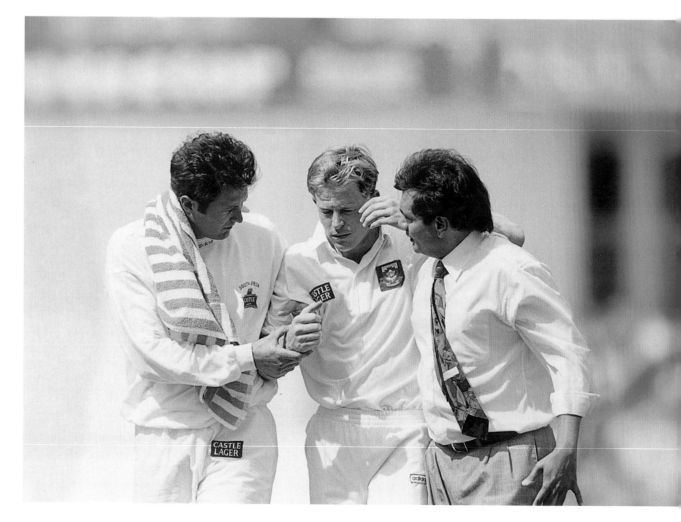

Left and below: **Stretching my infamous hamstrings. With Craig Smith in Sharjah, 1996 and Islamabad earlier the same year.**

Jonty – In Pictures

being selected for the first team when I was twelve years old
and still in standard four. I batted 10 and didn't bowl, so even
then I was probably in the team for my fielding.

So I've dived head first and feet first into advertising boards,
thrown myself all over the field, but the ball has done more
damage to me than anything else. The moral of the story is
don't do anything in a half-hearted manner, because you'll get
hurt.

**Hazards of the job. Receiving an ice pack from Craig Smith and
about to apply it to the troublesome hamstring.**

I think I'll stick to cricket. In Colombo in 2000 I injured my ankle in training while playing touch rugby. Luckily Craig Smith patched me up in time for the Test against Sri Lanka.

Paving
Jonty – In Pictures
The Price

Beating the pain barrier. Indian outfields are particularly nasty for fielders of my type. Here I'm wearing elbow guards to try and ward off the effects, but you can guarantee I woke up the next day with a couple more 'roasties' for the collection.

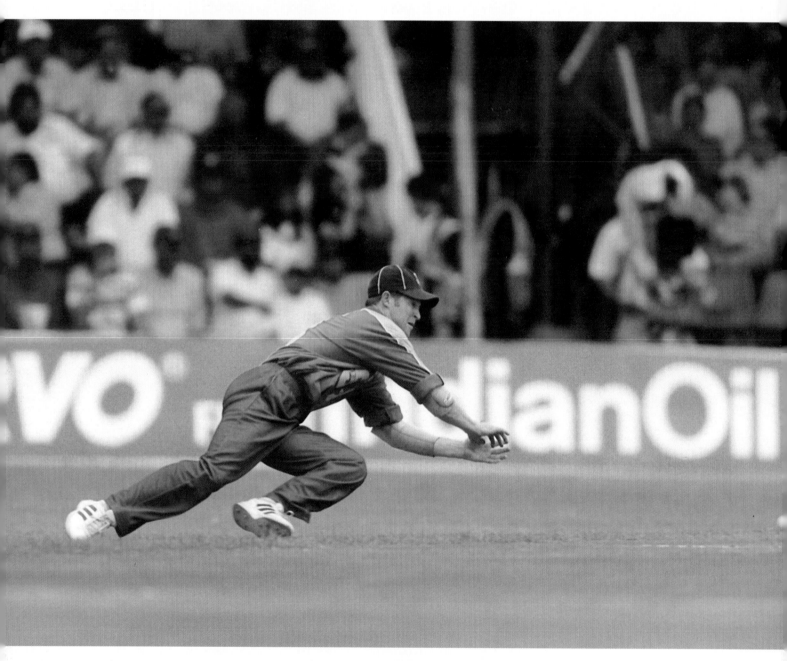

The 1999
World Cup

In 1999 we were all round a much better side than in 1996, but our performances didn't do us justice. Lance Klusener got us to the semi-final almost single-handed. Against Sri Lanka and Pakistan he smashed the bowling at the end of the innings and he won games where we were out of it.

We didn't play well against Zimbabwe and although that defeat turned out to be irrelevant it showed us that we had cracks. We've been labelled as chokers, which really irritates me because we've won many more finals than we've lost. A lot of that stuff comes out of Australia where they try to put doubt into your mind, something that they're very good at.

In '99 the one game we played really well, against Australia at Headingley, we lost. We scored over 300, had them 60-3 and then Herschelle Gibbs dropped Steve Waugh. But again you have to give credit to the brilliance of Steve Waugh because first of all he took advantage of the drop and then he identified an area of weakness and exploited it.

What happened was that Jacques Kallis picked up an injury and couldn't bowl, so our fifth bowler option was a combination of Hansie and Nicky Boje. Steve identified the only area where we were weak, took them for seven or eight an over and won the game.

In the semi-final we bowled well and early on I spoke to Hansie in the field. We agreed that it was a tough wicket where we had a chance to bowl Australia out for about 170. But Steve Waugh got runs again, so did Michael Bevan and of course, they got 213.

That was a good score in the conditions and we knew we had to bat really well to get it. We had a great start through Gary Kirsten and Herschelle Gibbs, but Shane Warne came on and in three overs he turned the game on its head. He got both the openers and then Hansie was given out, caught off his toe.

Then Daryll Cullinan went in and although he and Jacques consolidated, the Australians could feel that they were back in the game. When the last over of the match was bowled I was sitting on the balcony with Hansie, Bob Woolmer, Craig Smith and Peter Pollock and all the other players were inside the dressing room because they thought we'd lost.

This was taken in Hove before the 1999 World Cup began. We had a training camp in South Africa before leaving for England and I sprained my thumb and got tendinitis in my left arm from paddling on the river. The reason I'm all wrapped up is that I'm not taking part in the net session. I look like an undercover agent and maybe the reason is that we were practising to use the earpieces on the field that eventually got banned. So maybe it wasn't that cold, but I've got a beanie on to cover the earpiece!

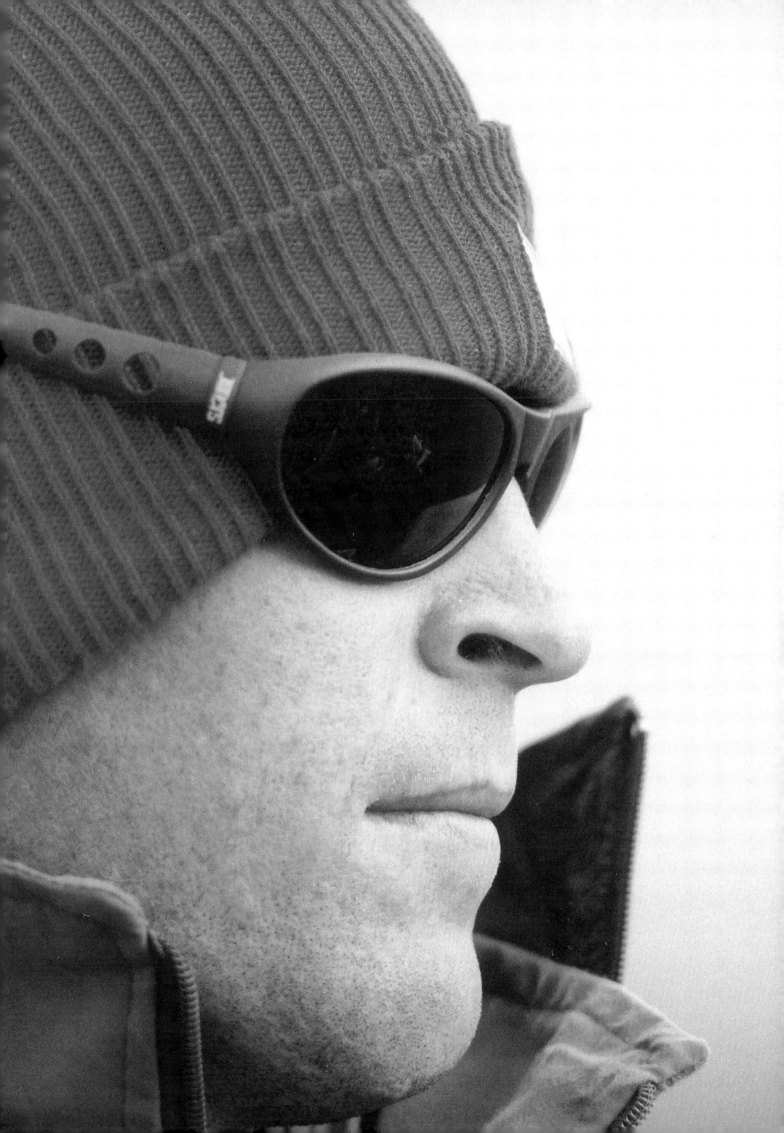

I had watched Lance Klusener for the whole tournament doing these amazing things and I just thought that as long as he was there we had a really good chance of winning. Damien Fleming went round the wicket and Lance smashed the first two through extra cover for four, scores are tied.

But there's a superstition in the team that if you're sitting somewhere and a partnership develops you don't get out of your seat. You don't go to the toilet, you don't have a drink, you just sit there. Well, Hansie had been sitting down all the time that Lance was winning the game and when he hit his second boundary he got up to go to the door so that he would be able to run on to the field and congratulate him.

Below: **What every fine-leg would like to have. The St Lawrence Ground in Canterbury has a tree inside the boundary, which counts as four if hit. We practised here before one of our matches.**

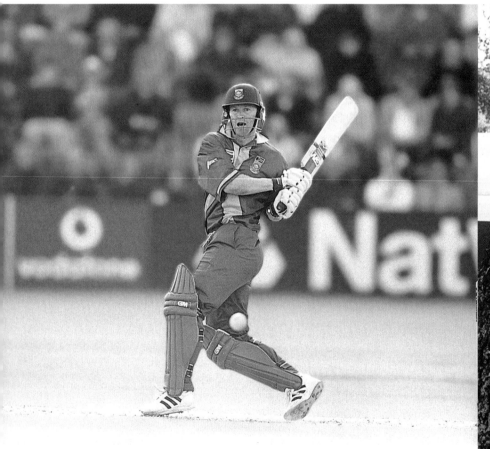

Above: **One off the middle. Batting against India in our opening game at Hove. There was some criticism of the venue, not because there's anything wrong with it, but there was such a demand for tickets they could have sold it out three times. In retrospect we probably should have played them at a Test ground.**

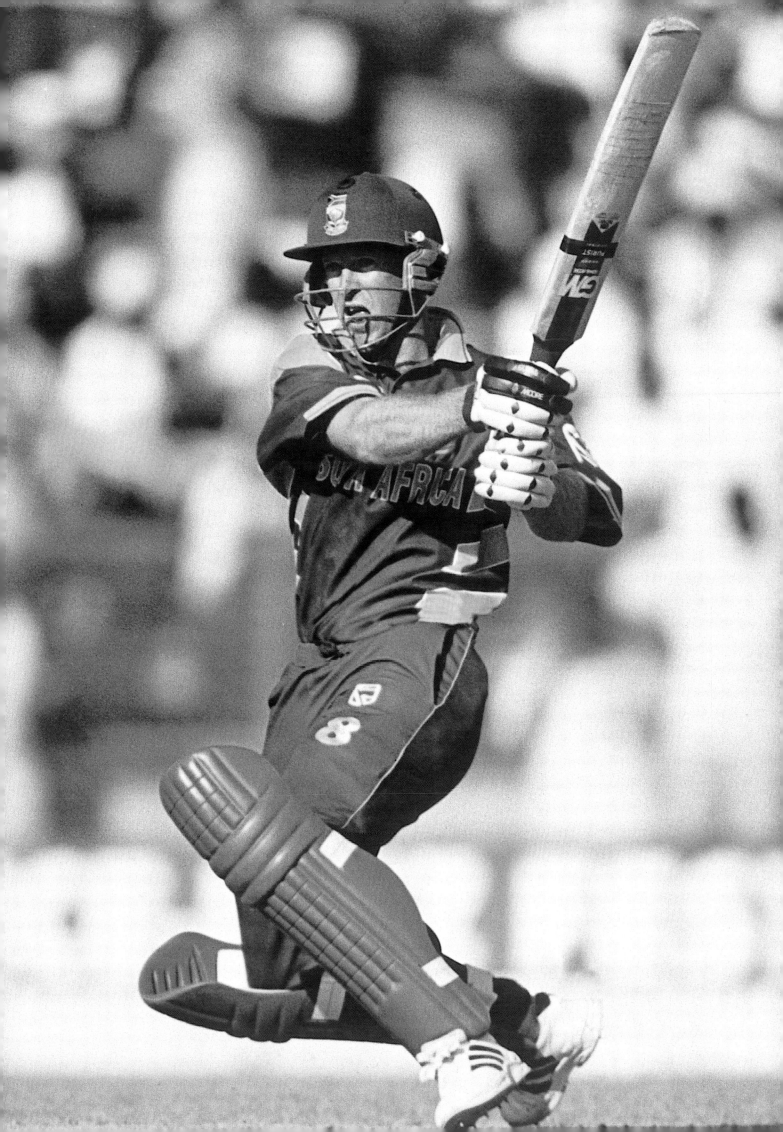

The 1999 World Cup

Jonty – In Pictures

The whole of South Africa knows what happened next. It still plagues me. I did an article recently with questions about my favourite and least favourite things and there was a question that asked what is the worst thing you've been forgiven for. I haven't done too many bad things in my life, so that wasn't a problem, but the next question was, what's the worst thing you have forgiven someone else for and I wrote, 'Allan Donald dropping his bat and not making it for one'.

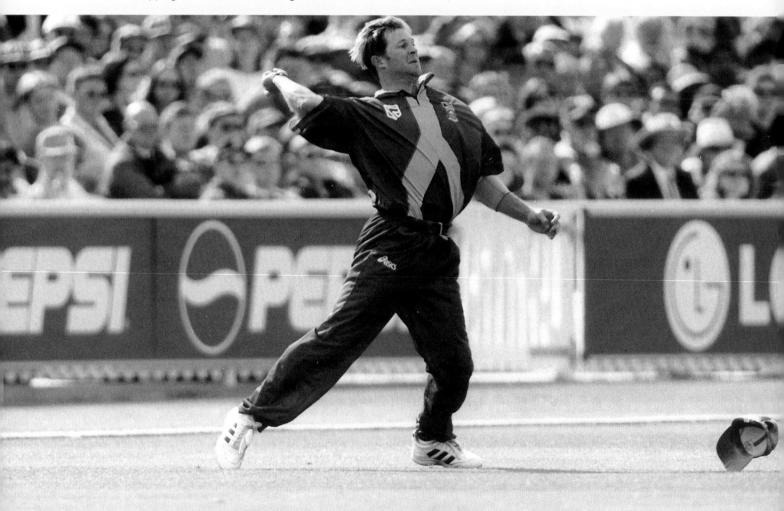

Slide Jonty, slide. This is the moment after I've jack-knifed out of the slide and have to get the ball back in. My balance is not great, my weight's going backwards instead of forwards. I discovered it's very difficult to teach this technique. I went to a coaching course at the Sports Science Institute and spoke to the guys about fielding and when I walked through the slide I got it wrong. Jimmy Cook said, 'I'm sure your knee's not there when you slide' and I'm thinking, well I don't know where my knee is, I just do it. It's not something that I've worked on and as a result it's hard for me to teach people how to do it.

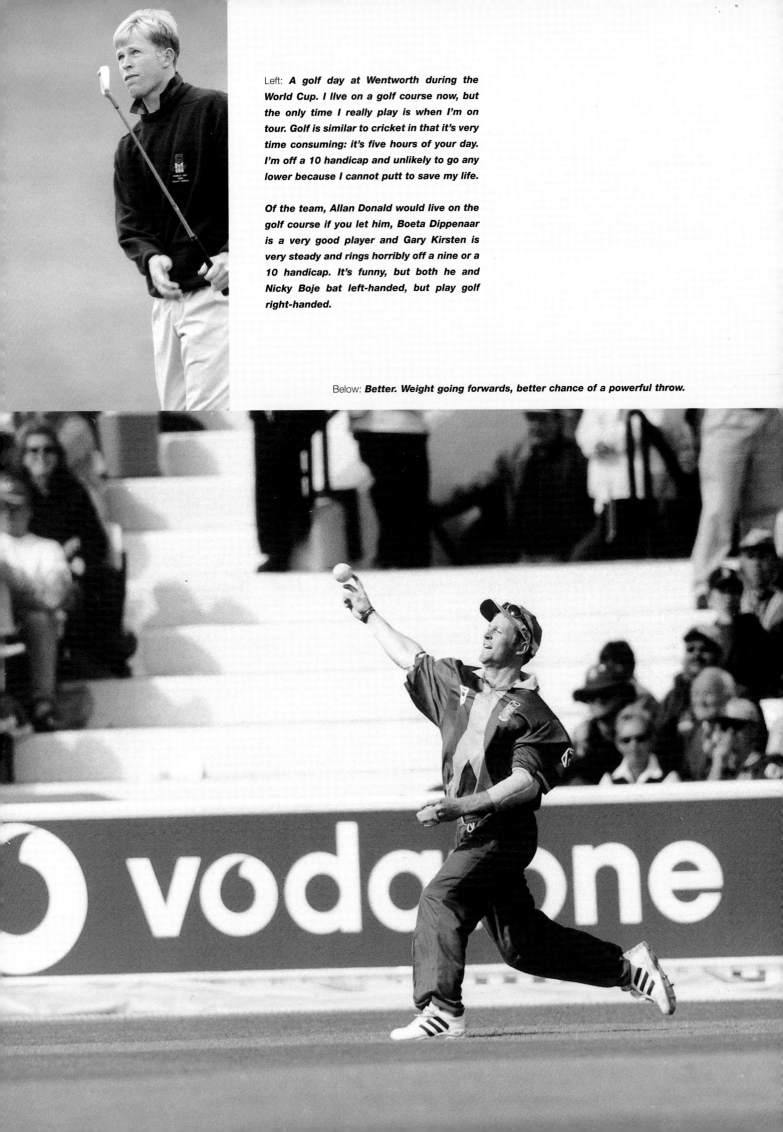

Left: *A golf day at Wentworth during the World Cup. I live on a golf course now, but the only time I really play is when I'm on tour. Golf is similar to cricket in that it's very time consuming: it's five hours of your day. I'm off a 10 handicap and unlikely to go any lower because I cannot putt to save my life.*

Of the team, Allan Donald would live on the golf course if you let him, Boeta Dippenaar is a very good player and Gary Kirsten is very steady and rings horribly off a nine or a 10 handicap. It's funny, but both he and Nicky Boje bat left-handed, but play golf right-handed.

Below: *Better. Weight going forwards, better chance of a powerful throw.*

The 1999 World Cup

Jonty – In Pictures

Right: ***Trying out a new elbow guard.***

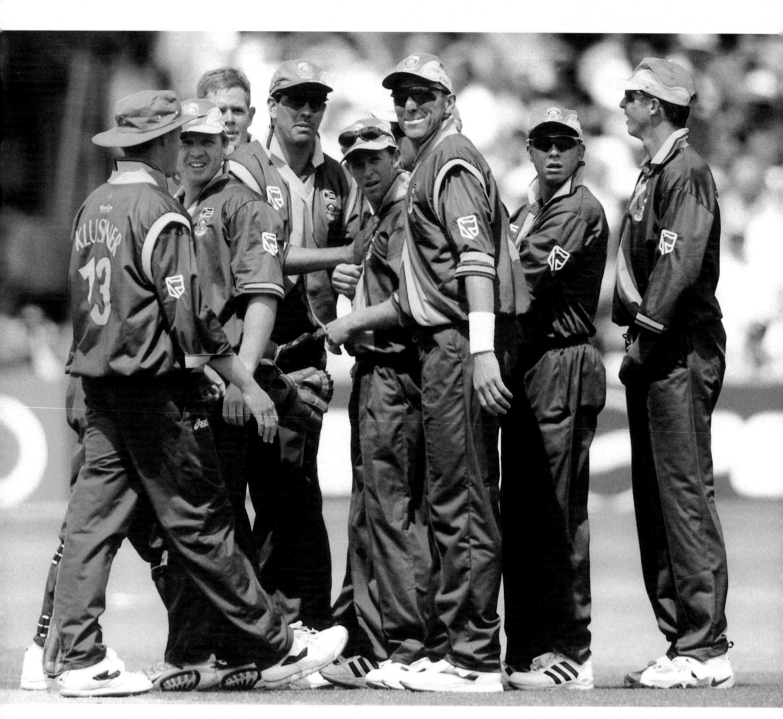

Celebrating a wicket for Shaun Pollock. From left: Lance Klusener, Daryll Cullinan, Polly, Hansie Cronje, Jonty, Allan Donald, Herschelle Gibbs and Steve Elworthy.

Right: ***Directing the traffic.***

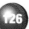

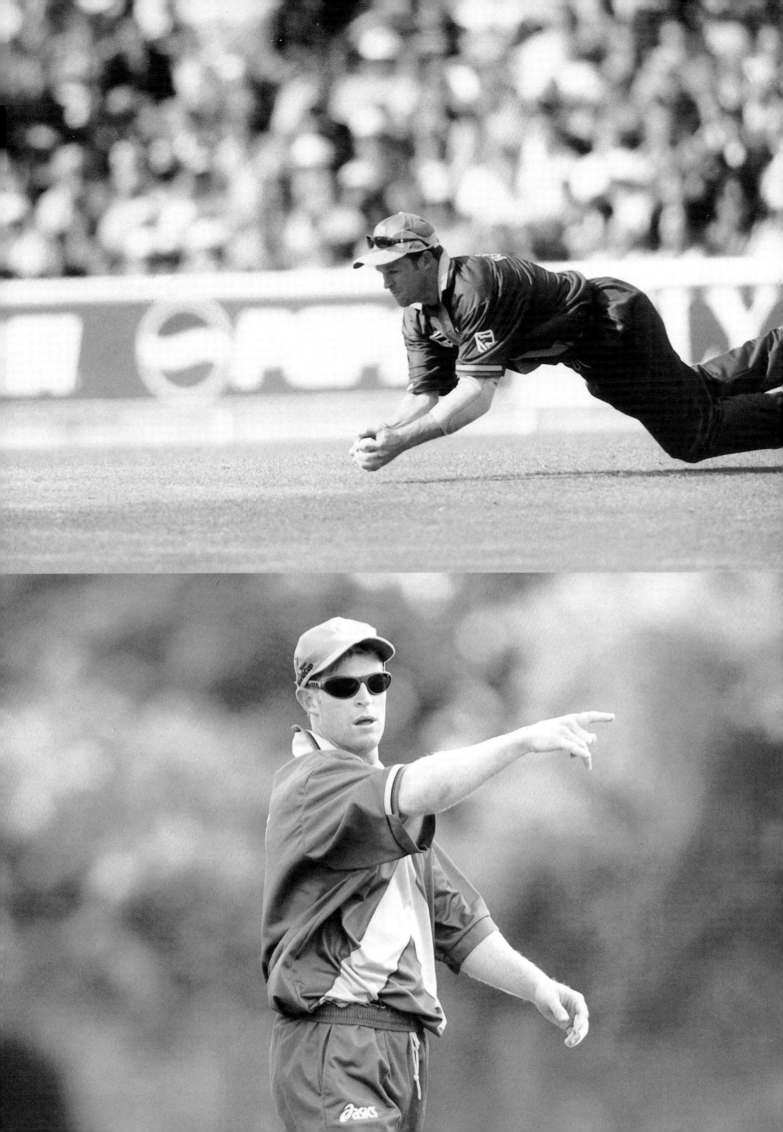

The 1999 World Cup

Jonty – In Pictures

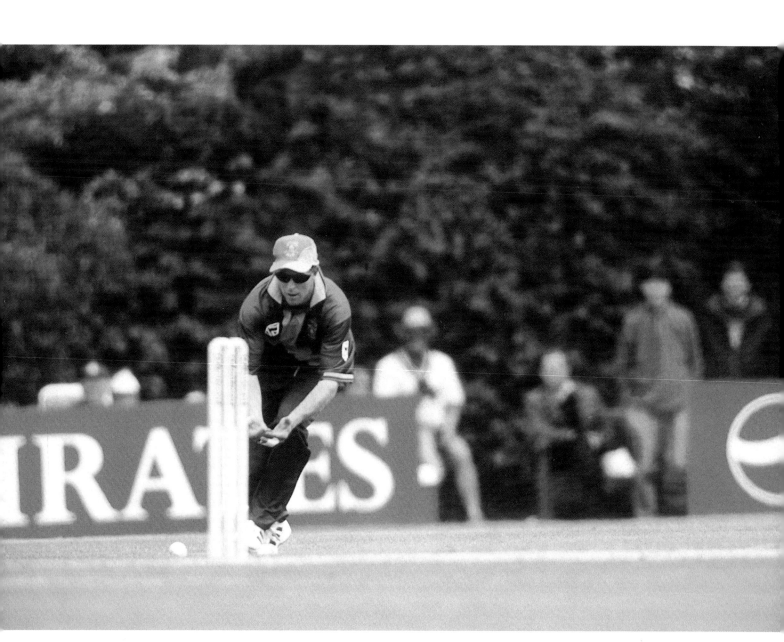

Warming up at Uxbridge, outside London at the '99 World Cup.

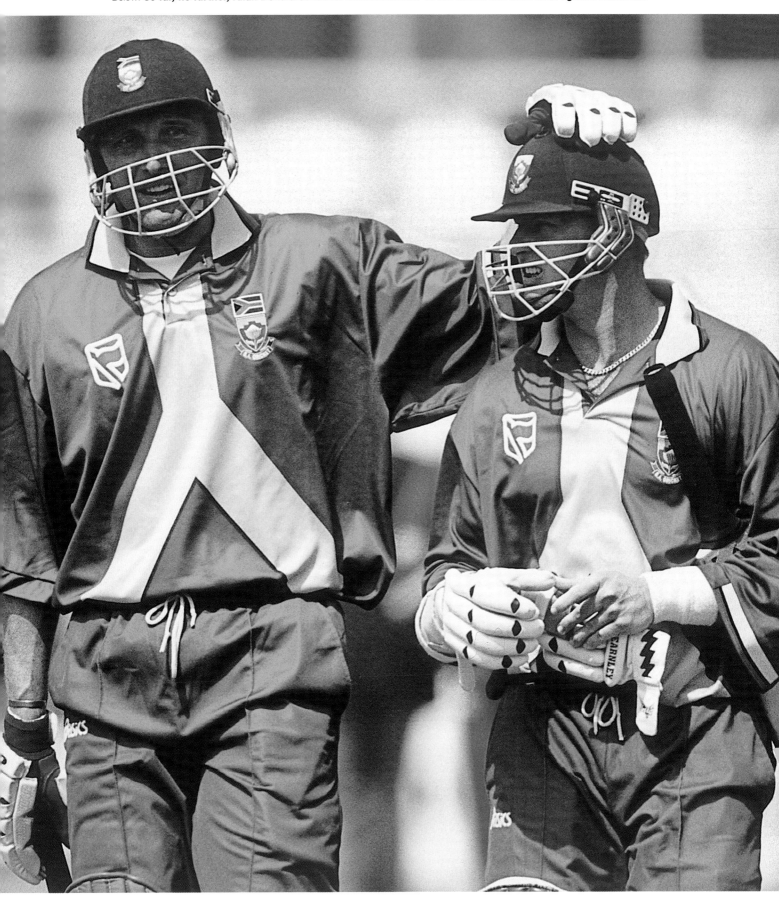

Jonty – In Pictures

Below: **Donald run-out. Where did all those Aussies come from? Allan Donald cuts a lone figure in a sea of canary yellow. He's at one end, his bat is at the other end and Australia have reached the final at our expense.**

Right: **Steve Waugh does it again. He got runs in both of the matches we played against Australia, both times we were on top and apparently winning the game.**

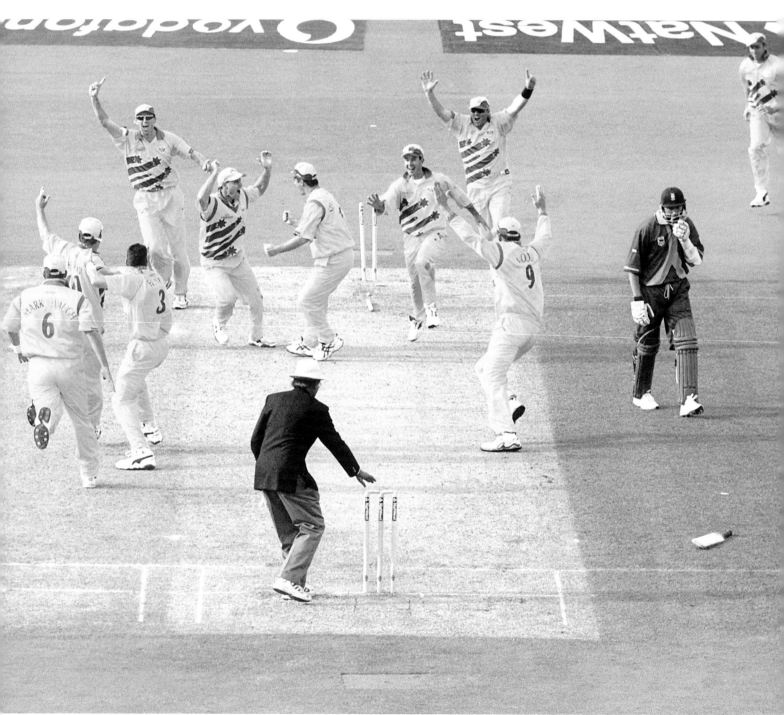

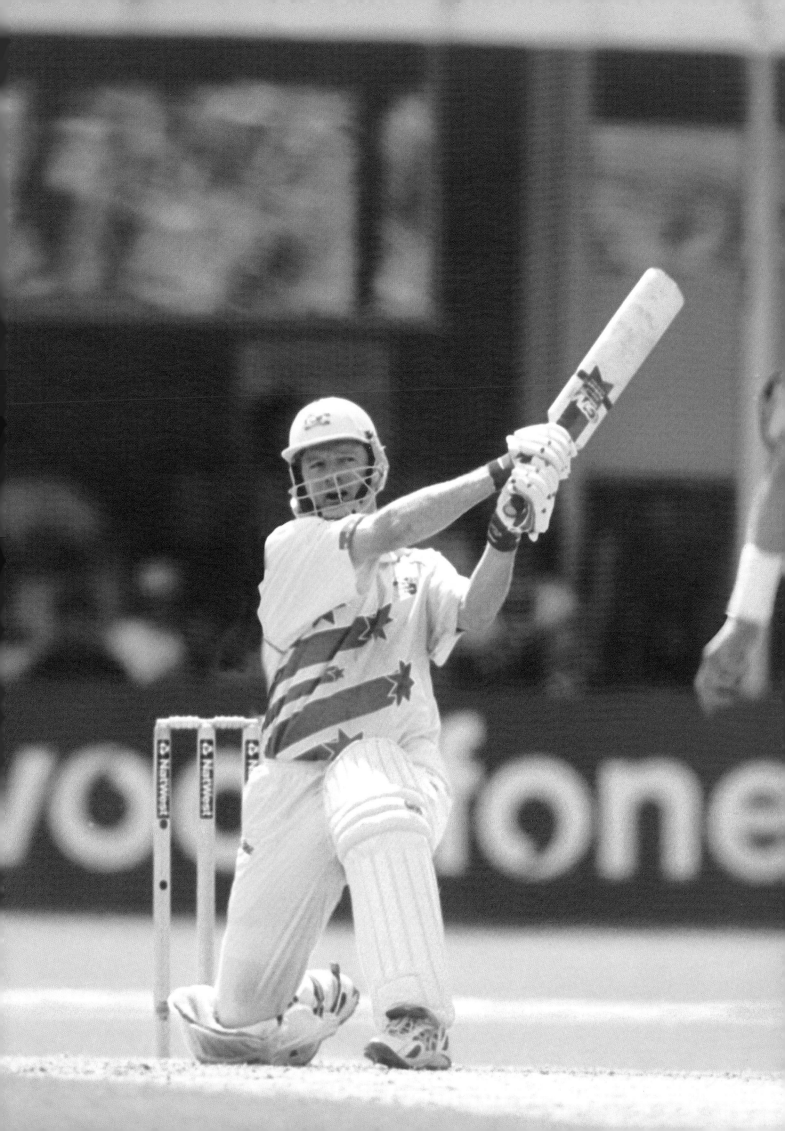

Jonty and Polly. Two Natal boys huddling together to keep warm in the English summer.

Cricket Under Cover

Cricket Under Cover

Jonty – In Pictures

In August 2000 we played a three-match series against Australia at the Colonial Stadium in Melbourne. What made it unique was that we played indoors. Like the Millennium Stadium in Cardiff, the venue of the 1999 Rugby World Cup final, the Colonial Stadium has a retractable roof and the pitch can be grown somewhere else and moved in.

People thought that the roof would be a problem in that the big hitters would be able to reach it, but in reality it is a massive carry and only Lance Klusener managed to hit it and that was in practice with people lobbing the ball to him to see what would happen.

The roof wasn't a problem, but the lighting was. We are used to playing at grounds with tall pylons, but at the Colonial Stadium the lights are under the roof. That meant that every time the ball went above head height it got lost in the lights, which made it very difficult for the fielding side. Another problem was the outfield. Melbourne doesn't get much sun, so even when the roof is open the grass doesn't have great growing conditions.

Two weeks before we played, there was an Aussie Rules match played there and the players complained about the outfield then. So when we walked on to the field for the first game we were amazed to discover that the ground staff had painted the mud green so that it would look better for television!

The magnificent Colonial Stadium in Melbourne. The roof is retractable, but we had trouble with the lights because they are too low for cricket. Note the small crowd. Australians don't go to cricket matches in August.

You couldn't get any purchase with spikes and in addition to everything else the matches weren't sold out, so the atmosphere left a little to be desired. In these pictures you'll also notice that there's a lack of clarity and that's not the fault of the photographers, it's because of the positioning of the lights. I wouldn't call the Colonial Stadium a failed experiment, but I also wouldn't say it's the future of cricket.

But having said all that, the series did produce some great cricket. We had beaten the Aussies 2-1 in South Africa and this series couldn't have been closer with one match won by either side and the other a nerve-racking tie. In one-day cricket we are very well matched and this was almost a continuation of the two games we played against each other in the 1999 World Cup.

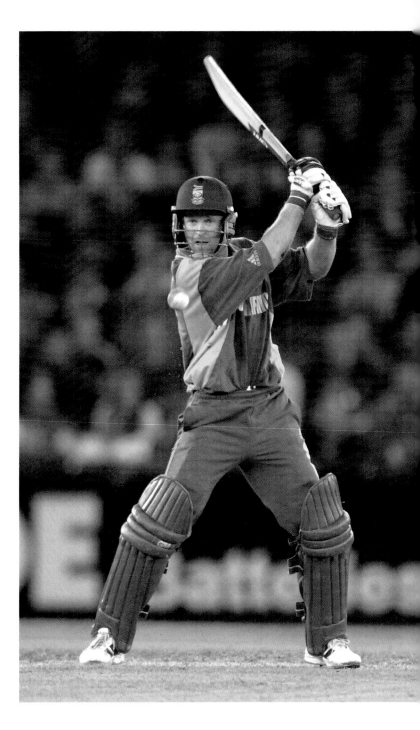

The slightly odd stance is because I tore my groin turning for a third run, but carried on batting.

Right: *The new Jonty pushing a single into the covers. This might look ungainly, but I've got well forward, made a good platform and opened the face to beat the cover fielder. Look how level my eyes are, a sign that I've watched the ball all the way on to the bat.*

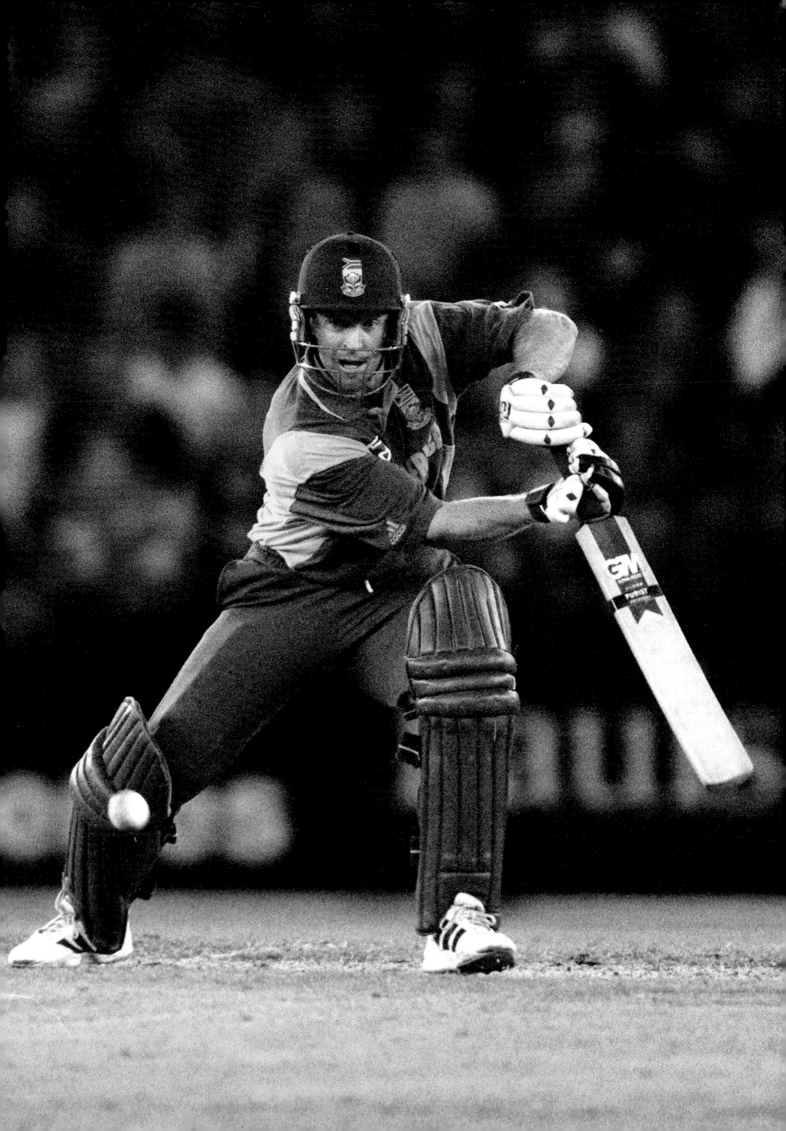

Jonty – In Pictures

Below: **Steve Waugh is wondering what all the fuss is about, I've only strained my groin, not broken my leg. Craig Smith does the needful.**

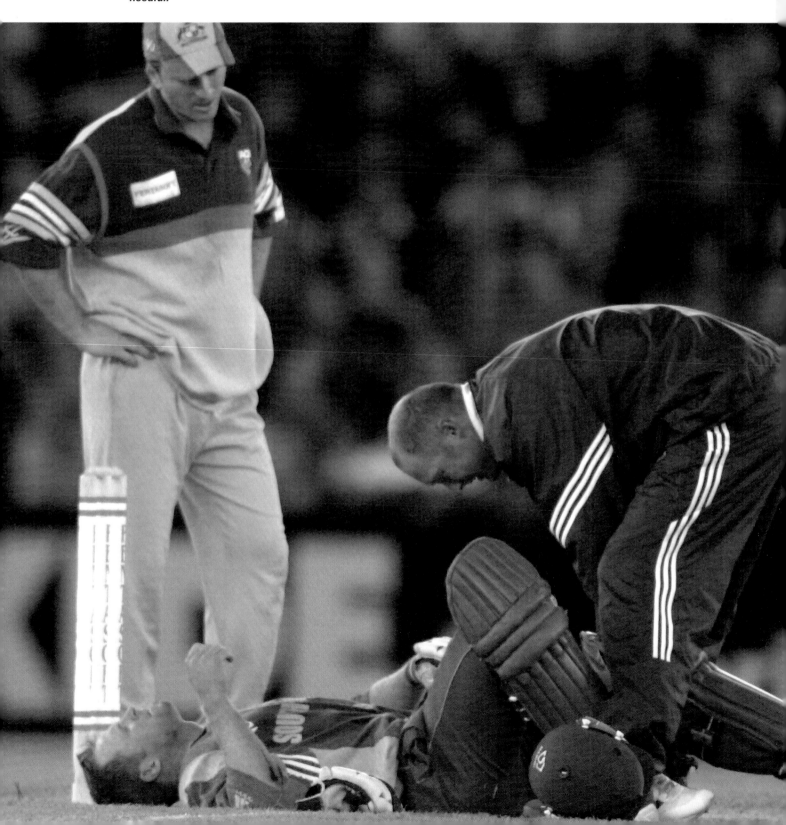

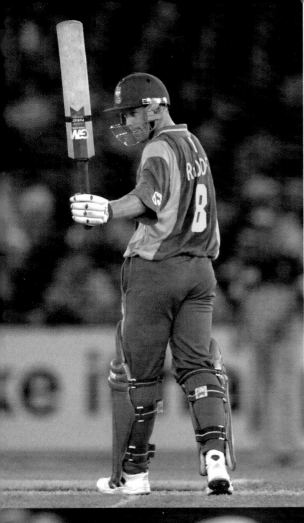

Left: *Acknowledging the applause of the crowd for reaching 50 on one leg.*

Below: *Mood indigo. Caught Shane Lee, bowled Glenn McGrath 50. In the background Michael Bevan shares a joke at my expense with McGrath.*

www.jonty.co.za

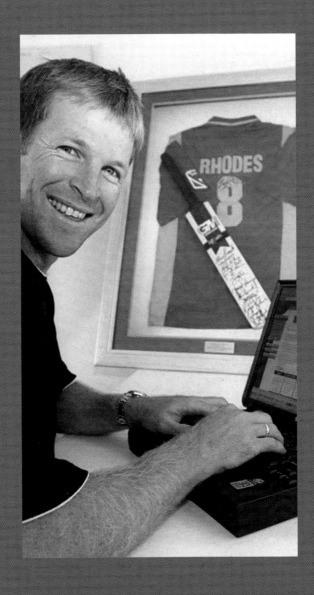

During his years in the game Jonty has built up a loyal fan base throughout the world. In response to the never ending requests for information there is now a website at www.jonty.co.za. Web surfers can subscribe to the monthly Jonty newsletter, buy memorabilia, receive coaching tips, win prizes and even book Jonty for a function.

There are pictures to download, a spot the ball competition, a cricket quiz and the latest news on Jonty. His dream teams for Tests and one-dayers are also on the site and in August 2001 this is what they looked like.

Test Team

1. Kepler Wessels
2. Michael Slater
3. Brian Lara
4. Sachin Tendulkar
5. Steve Waugh
6. Hansie Cronje (c)
7. Ian Healy
8. Wasim Akram
9. Shane Warne
10. Allan Donald
11. Courtney Walsh

Reasons:

If I had to pick anyone to bat for my life, it would be Kepler, and having him open with Slater would be the perfect foil, as Slater is such an aggressive player that the bowler's margin of error is drastically reduced. Lara and Tendulkar are two of the most destructive batsmen as they hit many boundaries and so score at a rapid run rate.

Waugh and Cronje are two of the most 'street wise' players I have ever seen, and they would be perfect players for the 'engine room' as they are able to adjust their games to whatever the situation requires – smashing shots, or dogged defence! Healy gets the nod ahead of Boucher due to my selection of Shane Warne as my spinner, as the two Aussies built up a deadly partnership that saw the demise of many an opponent.

Wasim Akram would be my all-rounder. He is such an asset in any team, as he is dangerous with the new ball, and even more of a threat with the ball once it is reversing. He also adds variation as a left arm seamer, and as an added bonus, is capable of hitting any bowler out of the attack. My new ball partners would be Donald and Walsh, as between the two of them they have been able to turn a game on its head with the dismissals of key opponents at critical times.

Hansie would captain the team, as he is the one person who would be able to get 10 other blokes from different backgrounds to combine as a single unit. In addition, he had a brilliant record as captain of SA, so he has the cricketing sense to go with his personality.

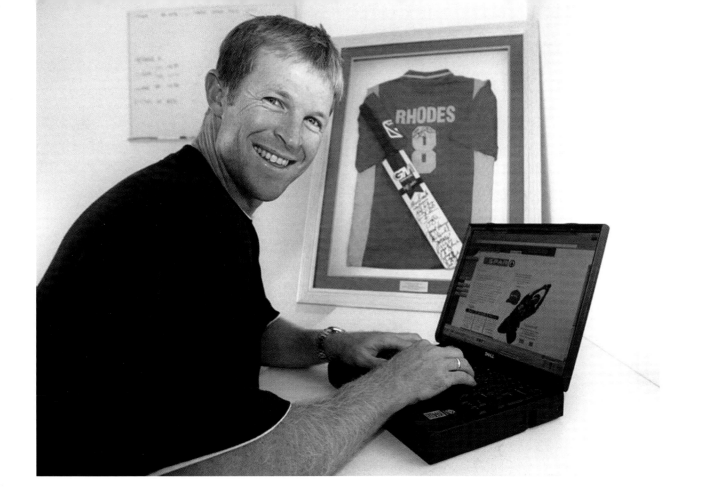

One Day International XI:

1. Sanath Jayasuriya
2. Sachin Tendulkar
3. Jacques Kallis
4. Steve Waugh
5. Hansie Cronje (c)
6. Michael Bevan
7. Mark Boucher
8. Shaun Pollock
9. Wasim Akram
10. Shane Warne
11. Glenn McGrath

Reasons:

Jayasuria gets the nod ahead of Mark Greatbatch, as even though the Kiwi batsman is just as destructive, Jayasuriya can also bowl a few overs of left arm darts. Kallis comes in for Lara as he is also an asset with the ball, and he can consolidate the innings if the team loses an early wicket.

Again, Cronje and Waugh can dictate the pattern of play in the middle order, and Michael Bevan is lightning quick between the wickets. He keeps Lance Klusener out of my side, as both are really good 'finishers' of the game, with very high averages combined with exceptional strike rates. His running between the wickets gives him the edge, as he can score for the other players by getting back to the non-striker's end for two when most players would settle for one.

Boucher comes in for Healy as Warne can only bowl 10 overs, and Gary Kirsten could probably handle that behind the stumps. Pollock and McGrath would take the new ball, and between them you would be lucky to get 3 bad balls in their combined 20 overs. Akram would wrap up the tail with his reverse swinging 'scuds', breaking both toes and stumps.